Contents

Introduction 5

Getting Started 6

Dublin Duo 8

Cabled
Boot Cuffs 14

Satinées Wine
Wristers 18

Silky and Chic Cowl 22

Aranmore Sweater
Wrap 26

One Big Braid Scarf 30

Tic-Tac-Toe
Messenger Bag 34

Fergus Shrug 38

Braids and Weaves Alpaca
Hat 44

Emerald Celtic Weave
Infinity Scarf 48

Purple Plaited
Poncho Wrap 52

Orlaith Robe Sweater 56

Celtic Cabled Cowl 62

Lavena Poncho 66

Vicki's Sweater 70

Binne Cardigan 76

Blue Moon Shawl 84

Stitch Abbreviations 91

Foundation Stitches 92

Special Stitches 100

Resources 124

Acknowledgments 125

Dedication 127

About the Author 127

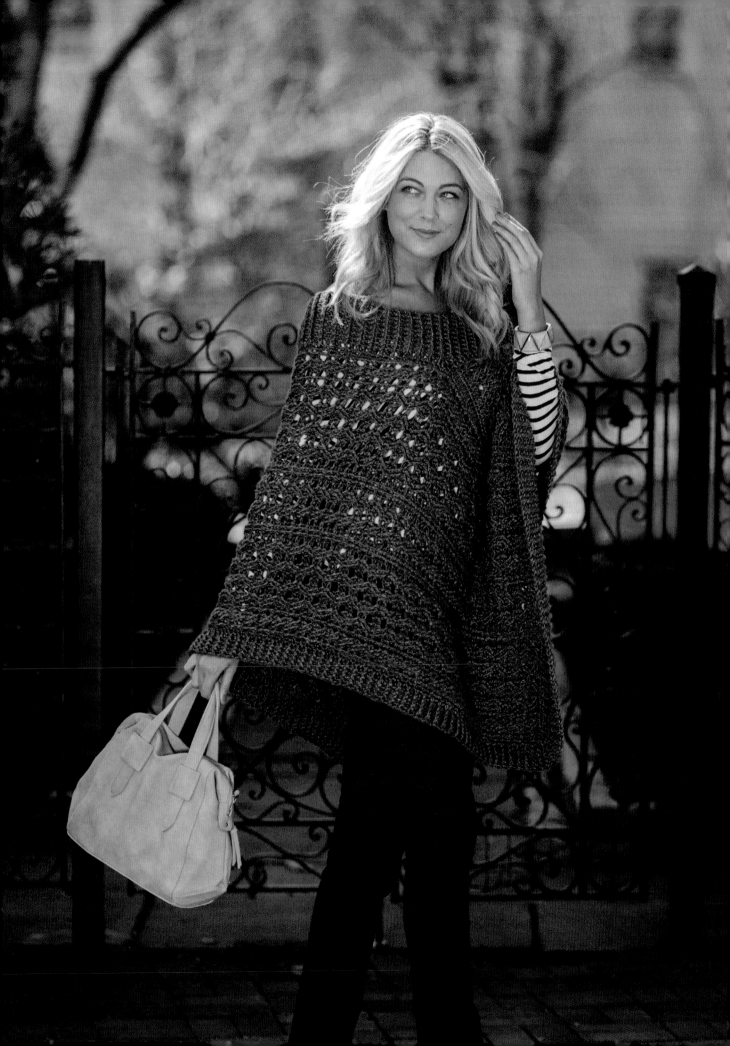

Introduction

As you already know, I am hopelessly in love with cables. Being able to crochet them with my beloved crochet hook has been a passion of mine for many years, and I lack the words to sufficiently express my gratitude for the opportunity to publish my very own cabled designs! After the release of my first book, *Contemporary Celtic Crochet*, I began hearing from many of you who share this passion for crocheted cabled motifs. Your encouragement has been so overwhelming to me and has fueled my desire to continue to explore the possibilities in this arena. I honestly think we have barely scratched the surface, hence this book of more of what we all crave!

In this book you will notice I have redesigned the larger crocheted cables, making them more elegant and appealing to the eye than some of the (forgive me for saying) clumsier versions of previous decades. By making some subtle adjustments to how the cables are crocheted and combined with the vast choices of lighter-weight yarns, larger, bolder cables are now more viable. To borrow a 1970s phrase from the Carpenters on this new approach, "We've only just begun!"

The designs in this book continue where the last book left off. I hope you find many of the things you enjoyed in the first book, as well as some refreshing new approaches to what can be accomplished using the most fundamental crochet stitches and basic crochet hook. It is my hope any crocheter—from the confident beginner to the seasoned— will be able to accomplish any of the patterns within this book. Some of the designs are more simply stated and would be very helpful learning projects, while others have more complex cabling to keep advanced crocheters challenged and growing in their skill. You may also recognize these designs have a classic, stylish look, yet are functionally practical.

You will also notice I used a variety of different yarns, from fingering weight, to DK, worsted, and even bulky. I love to be able to finish a design quickly. But I also love the beautiful fabric that can be created with the finer yarns that require more time.

So grab your yarn and crochet hooks and come along with me for more cabled crochet!

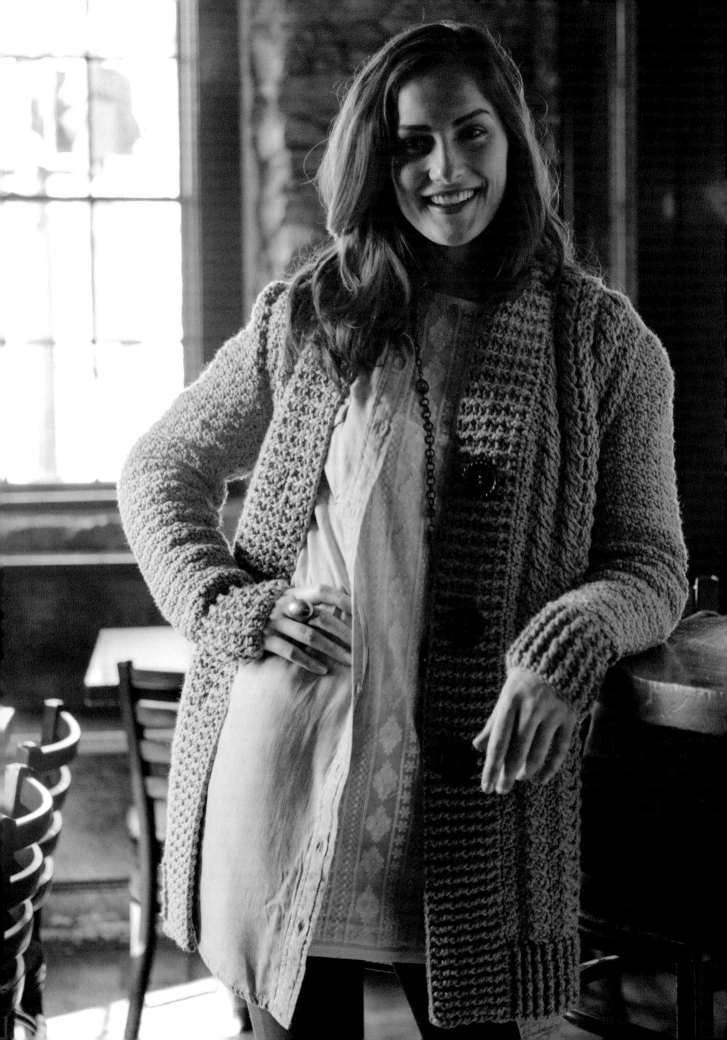

Getting Started

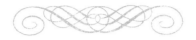

SO MUCH YARN, SO LITTLE TIME!

I want to share some fundamental information about yarn choices I've learned over the years. A great deal of thought has gone into yarn selection for each of these designs, and I encourage you to try the yarns listed in order to get similar results. Of course you are free to crochet using the fiber of your choice. When it comes to yarn substitution, please remember yarns vary, even yarns that are in the same size category. Just like all four-year-old children don't look and behave the same, neither do all yarns labeled *4* (worsted weight) look or behave in the same way. Oh, if only life were as simple as that! Some yarns will have more drape, some will be stiffer; some scratchier, some softer; some will hold up to numerous washings, and others will not.

When choosing yarn for one of these projects, you will want to consider the needs of the person for whom you are making it. Will this be a gift for a child or active teen? Will it be a very special gift for someone? Does this person have allergies to wool or other fibers? Will this be for everyday wear or for special occasions? Do you want to be able to machine wash this item? Do you (or the recipient) have the time to follow special care instructions? I promise I'm not trying to make your life more complicated by asking these questions. But they are important to consider so you make the most of your time and the money you spend on yarn.

A GENTLE REMINDER ABOUT GAUGE

Being a teacher at heart, I have tried to do everything I can think of to help you be successful with the patterns in this book. Like many, I love to just grab some yarn and jump into a pattern! If that is you too, please take some time to work a gauge sample for each design before starting a project. I promise it will save the anguish and frustration of having to rip out a project after investing hours of your time. This will also give you a little bit of practice to work out some of the newer stitches. Should you need to go up to a larger hook or down to a smaller hook in order to make proper gauge, by all means change the hook! There is absolutely nothing sacred about the size or type of crochet hook you use, as long as you can make the proper gauge.

GOT YOUTUBE CROCHET VIDEOS?

Should you ever need extra help beyond the stitch dictionary located at the back of this book, feel free to check out my Bonnie Bay Crochet Channel on YouTube. It is available here: www.youtube.com/user/BonnieBayCrochet. (You will need Internet access to view these videos.)

All stitch videos are intended to be a supplementary help. The pattern directions are always primary! The purpose of the videos is to demonstrate a stitch, not to teach a pattern. If you find any differences in a video from the pattern, *always follow the pattern!*

TURNING CHAINS

If you are a seasoned crocheter, you may have noticed I don't use standard turning sizes. Generally, I chain 2 for half double crochet and double crochet and chain 3 for treble crochet. The main reason for this is to avoid having gaping holes along the sides in the designs. Consider this use of my artistic license! Once you complete a pattern or two, you'll understand my rationale.

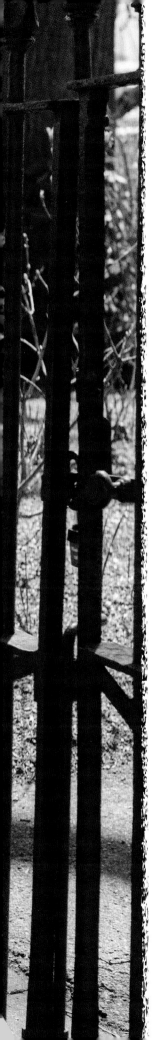

DUBLIN DUO

This is a fun and easy project for the confident beginner who has learned
the basic crochet stitches and is ready to learn a simple,
yet beautiful, crocheted cable.

SKILL LEVEL
Beginner to Intermediate

YARN
Worsted (#4) weight.

Shown here: Blue Sky Alpacas Extra (55% baby alpaca, 45% fine merino wool; 218 yd [199 m]/150 g): #3512 Cherry Blossom, 3 hanks.

HOOKS
Size J/10 (6 mm).

Adjust hook size if necessary to obtain gauge.

NOTIONS
Yarn needle.

FINISHED DIMENSIONS
Scarf: 59" × 5½" (150 × 14 cm).

Hat: Approx. 21" (53.5 cm) circumference (with several inches [centimeters] of ease) and 11" (28 cm) from center of crown to end of brim when unfolded.

GAUGE
12 sts and 12 rows = 4" (10 cm) in sc.

SPECIAL STITCHES
Reverse Arrow, Low Back Ridge (LBR), Low Front Ridge (LFR), Single Crochet Ribbing

PATTERN NOTES
In scarf pattern, even rows will have the front side facing.

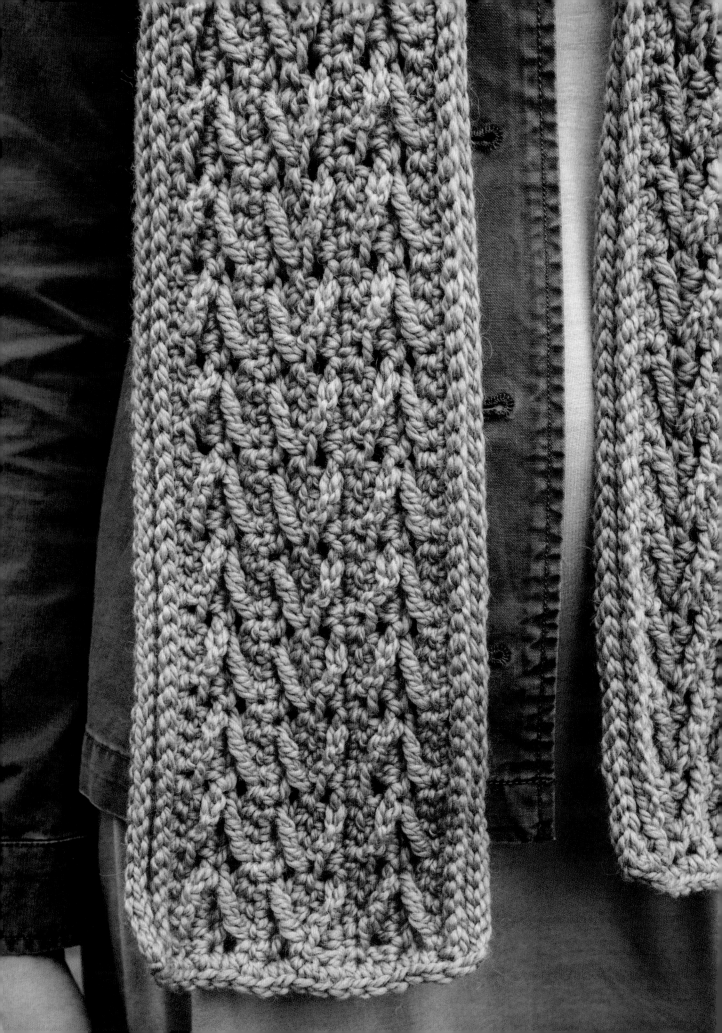

SCARF

Ch 187.

Row 1: Sc in second ch from hook and in each ch across, turn. (186 sc)

Row 2: Working in front loop only, slip st in the next sc and in each sc across, ending by working last slip st in turning ch, turn.

Row 3: Ch 1, starting in the first sc, sc in the remaining loops across row. Do not sc in turning ch. Turn.

Row 4: Ch 2, dc in first st, *sk next 3 sts, tr in next sc, working behind tr, dc in 3 sts just skipped; repeat from * across row, dc in last st, turn. (46 pattern repeats)

Row 5: Ch 2, dc in first st, *sk next 3 sts, tr in next sc, working in front of tr, dc in 3 sts just skipped; repeat from * across row, dc in last st, turn.

Row 6: Ch 1, sc across row, turn.

Row 7: (Reverse Arrow) Ch 2, dc in first st, sk 3 sts, *tr in next st, working in front of tr, dc in 3 skipped sts; repeat from * across row, dc in last st, turn.

Row 8: Ch 2, dc in first st, *sk 3 sts, tr in next st, working behind tr, dc in 3 skipped sts; repeat from * across row, dc in last st, turn.

Row 9: Ch 1, sc across row, turn.

Rows 10 and 11: Repeat Rows 4 and 5.

Row 12: Ch 1, sc across row, turn.

Row 13: Ch 1, working in the back loop only, slip st in the next st and in each st across and in the turning ch, turn.

Row 14: Ch 1, working in the remaining loop, sc in the next st and each sc loop across.

Perimeter Rnd: Continuing from Row 14, *ch 2 (for corner), rotate work 90 degrees to crochet along end of scarf. Work 17 sc evenly along end, ch 2 (for corner), rotate 90 degrees to work along long edge, slip st in each st across to next corner; repeat from * around. Join with a slip st in first st of round. Fasten off.

FINISHING

Weave in loose ends.

HAT

Ch 23.

Row 1: Sc in 2nd ch from hook and in each ch across, turn. (22 sts)

Row 2: Ch 2, dc in first sc, *sk 3 sts, tr in next st, dc in the 3 sts just skipped, being careful to work behind tr; repeat from * 4 more times, dc in last st, turn. (5 pattern repeats)

Row 3: Ch 2, dc in first st, *sk next 3 sts, tr in next st, dc in 3 sts just skipped, being careful to work in front of tr; repeat from * 4 more times, dc in last st, turn.

Row 4: Ch 1, sc in each st across, turn.

Row 5: Ch 2, dc in first st, *sk next 3 sts, tr in next st, dc in 3 sts just skipped, being careful to work in front of tr; repeat from * 4 more times, dc in last st, turn.

Row 6: Ch 2, dc in first st, *sk next 3 sts, tr in next st, dc in 3 sts just skipped, being careful to work behind tr; repeat from * 4 more times, dc in last st, turn.

Row 7: Ch 1, sc across row, turn.

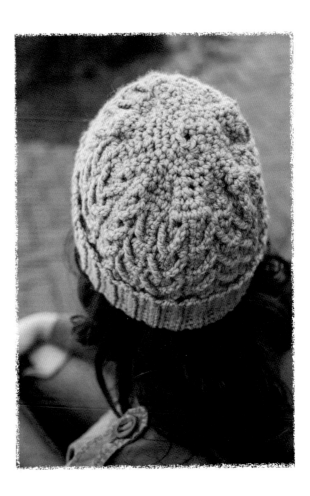

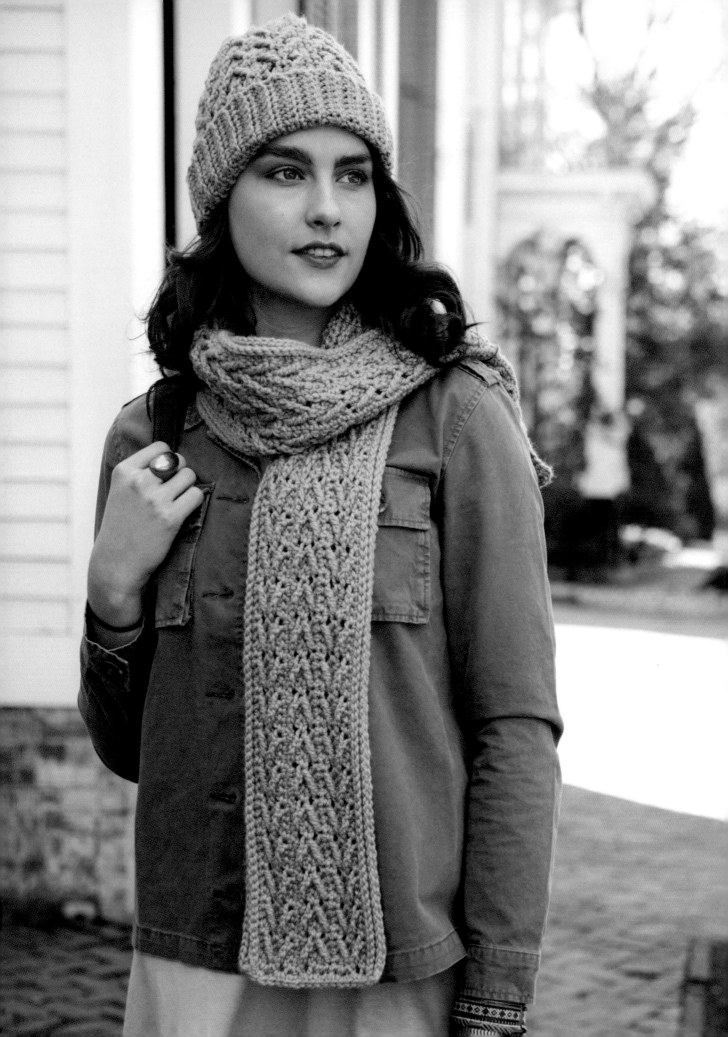

Rows 8–36: Repeat Rows 2–7 four more times; repeat Rows 2–6 once more.

At end of last row, ch 1, turn. With RS together, join with slip st in first ch of foundation ch row, working through both layers, slip st across 22 sts.

Piece should measure approx. 17¾" × 6" (45 × 15 cm).

CROWN

Row 1: With RS facing, ch 1, work 60 sc evenly around edge, join with slip st in first st (60 sc). Ch 1, do not turn.

Row 2: Work [sc, dec (pull up a loop in the next 2 sts, yo, pull through 3 loops on hook)] around, ending by working a sc in last st, join with slip st in first sc. (40 sts)

Row 3: Repeat Row 2, sc in last st. (27 sts)

Row 4: Repeat Row 2. (18 sts)

Row 5: Sc in each st. (18 sts)

Row 6: Repeat Row 2. (12 sts)

Row 7: Work 1 dec over every 2 sts. Fasten off. (6 sts)

BOTTOM RIBBING (Brim)

With RS facing, at seam, join with slip st to lower edge of Hat, ch 1, work 60 sc evenly around bottom edge of Hat, join with slip st in first sc. (60 sc)

Row 1: Ch 10. Sc in 2nd ch from hook and in remaining ch (9 sc), join with slip st in next 2 sc on Hat edge, turn.

Row 2: Ch 1, sk first 2 slip sts, sc in back loop only of each sc across, turn.

Row 3: Ch 1, sc in back loop only of each sc across, slip st in next 2 sc on Hat edge, turn.

Rows 4–60: Repeat Rows 2 and 3 around edge of Hat.

Joining Row: Ch 1, turn; matching sc on last row worked through both thicknesses, slip st in back loop only of sc and in opposite loops of starting ch across. Fasten off.

FINISHING

Weave in loose ends.

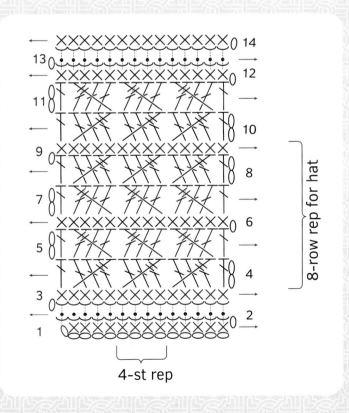

4-st rep

8-row rep for hat

STITCH KEY

- • slip st
- ⬯ chain (ch)
- ⌣ work in front loop only
- ✕ single crochet (sc)
- ⊤ double crochet (dc)
- ⫪ triple crochet (tr)
- ┈┈┈ indicates when stitches are worked in lower rows
- ⟶ indicates direction of rows or rounds

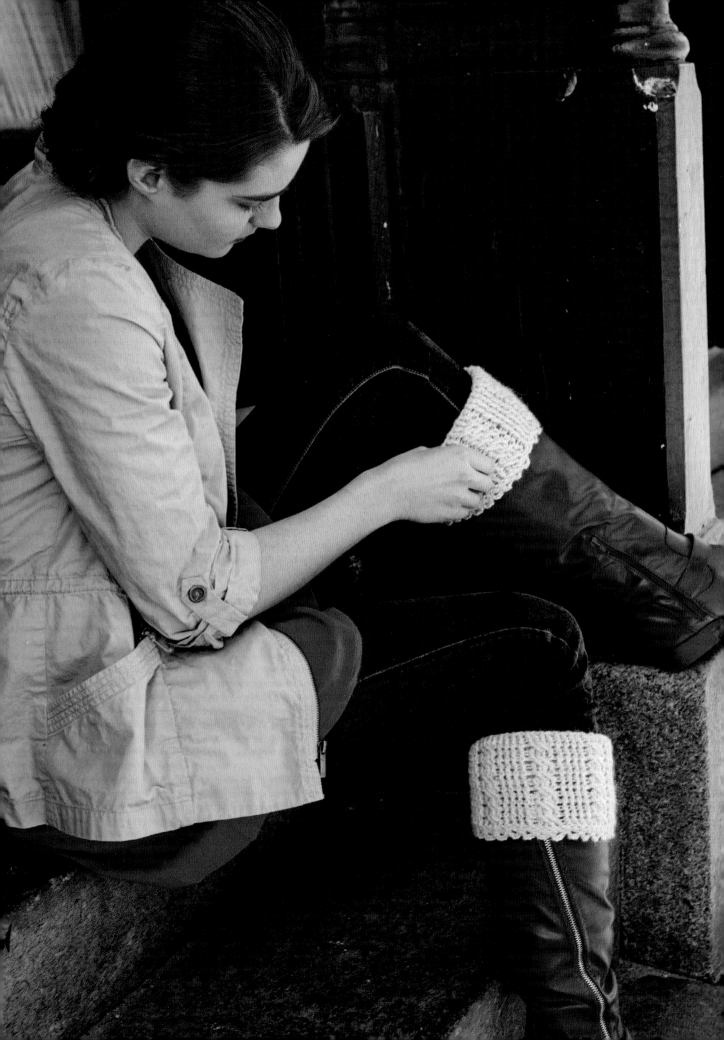

CABLED BOOT CUFFS

These Cabled Boot Cuffs are pure luxury when preparing to brave the cold winter wind and snow! Wear your cuffs as tall socks above your boots, or fold them over the outside of the boots, displaying your beautiful crocheted cabling for everyone to see. Either way, it will give you another way to enjoy the cold!

SKILL LEVEL
Confident Beginner to Intermediate

YARN
DK (#3) weight.

Shown here: Blue Sky Alpacas Melange (100% baby alpaca; 110 yd [100 m]/50 g): #809 Toasted Almond, 3 [4, 4] hanks.

HOOKS
Size G/6 (4 mm).

Adjust hook size if necessary to obtain gauge.

Size E/4 (3.5 mm) crochet hook for edging.

NOTIONS
Yarn needle.

FINISHED DIMENSIONS
X-Small/Small: 8" long × 11" circumference of upper section (20.5 × 28 cm) with approx. 2½" (6.5 cm) of ease.

Medium/Large: 8" long × 12½" circumference of upper section (20.5 × 31.5 cm) with approx. 3" (7.5 cm) of ease.

X-Large/2X: 8" long × 14" circumference of upper section (20.5 × 35.5 cm) with approx. 3½" (9 cm) of ease.

For even larger sizes, add 8 sts to starting ch to add 1½" (3.8 cm) to width.

GAUGE
20 sts = 4" (10 cm), 7 rows = 2" (5 cm) in ribbing pattern (fpdc, bpdc) with larger hook.

SPECIAL STITCHES
Four-Stitch Post Cable, Ribbing Using Front Post and Back Post

PATTERN NOTES
These cuffs are worked in the round.

Ch 2 does not count as a stitch in stitch count.

Instructions given for size XS/S, with larger sizes (M/L, XL/2X) in parentheses.

CUFFS (Make 2)

Using larger hook, ch 48 (56, 64), slip st to the first ch to form a ring, being careful not to twist ch.

Rnd 1: Ch 2, dc in same ch as joining and in each ch around. Join with slip st to top of first st. (48 [56, 64] sts)

Rnd 2: Ch 2, [fpdc, bpdc] around. Join with slip st to top of first st.

Rnds 3–12: Repeat Rnd 2. At the end of Rnd 12, turn.

Rnd 13: (WS) Ch 2, bpdc around. Turn.

Rnd 14: (RS) Ch 2, [fpdc in first 4 sts, sk 2 sts, fptr in next 2 sts, working in front of these sts, fptr in 2 skipped sts] around. Join with a slip st to top of first st of rnd. Turn.

Rnd 15: Repeat Rnd 13.

Rnds 16–25: Repeat Rnds 14 and 15 five more times.

Change to smaller hook to work final rnd.

Rnd 26: (Eyelet trim) Ch 1, ★[sc, ch 4, dc] in next st, sk next st. Repeat from ★ around. Join with a slip st to beg of rnd. Finish off.

FINISHING

Weave in loose ends.

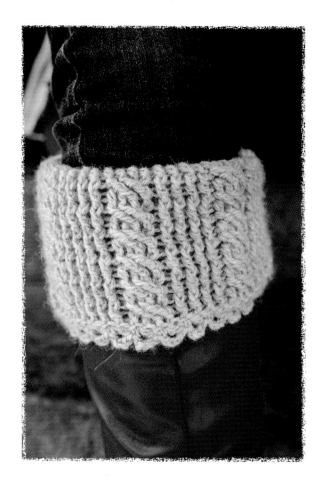

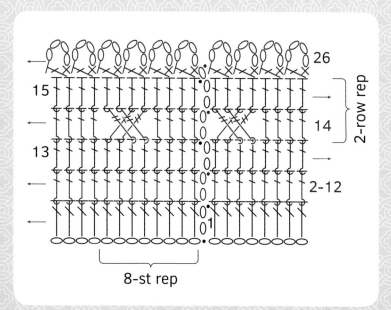

STITCH KEY

- • slip st
- ◯ chain (ch)
- ✕ single crochet (sc)
- ⊤ double crochet (dc)
- ⊤ front post double crochet (fpdc)
- ⊤ back post double crochet (bpdc)
- ⊤ front post treble crochet (fptr)
- → indicates direction of rows or rounds

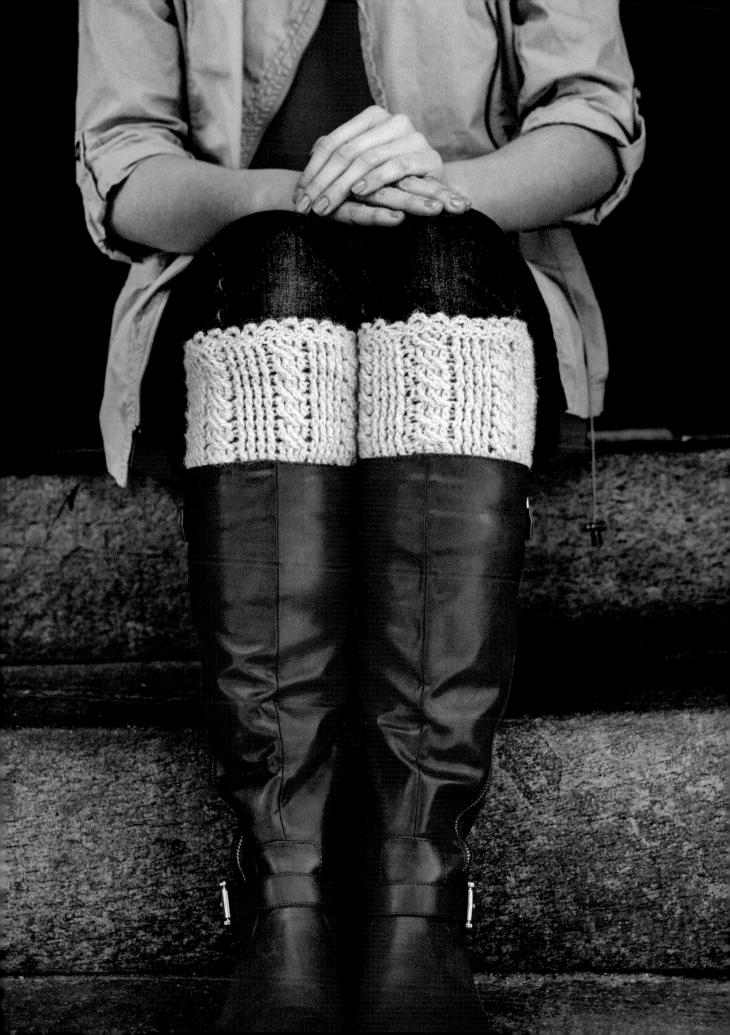

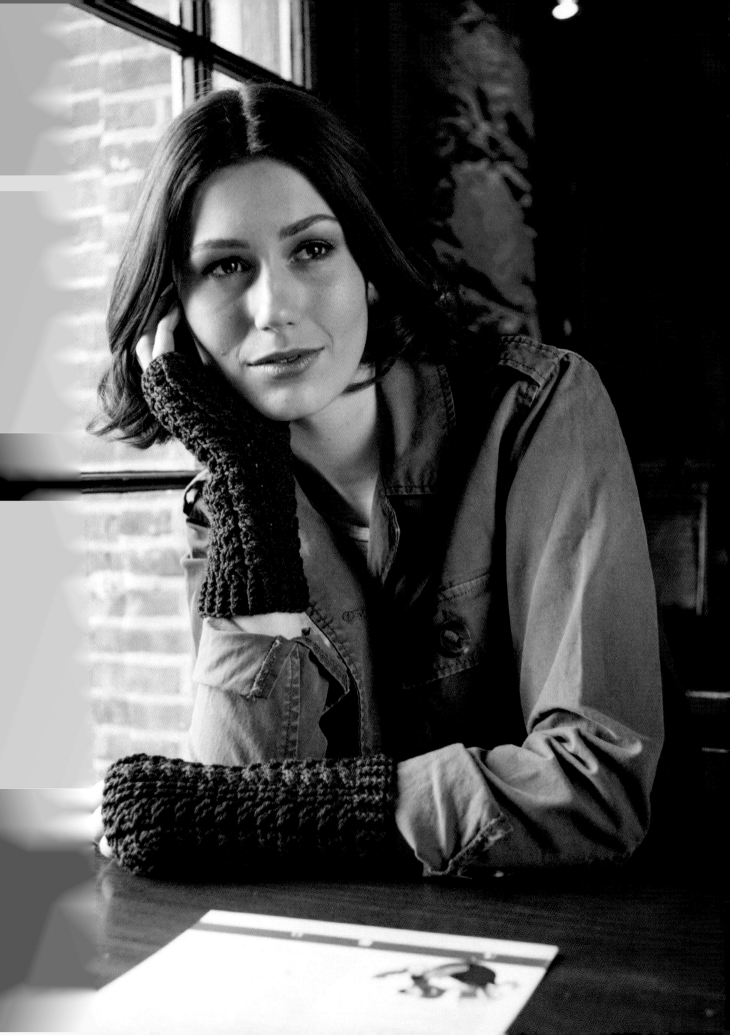

SATINÉES WINE WRISTERS

The Satinées Wine Wristers are a beautiful way of keeping your hands warm around the house on those cold days, yet they allow you the flexibility of having the use of your fingers to accomplish your important tasks with ease. You'll be amazed at how quickly these are completed and just how comfortable they are to wear. The natural properties of the wool/silk blend will stretch and give to perfectly accommodate your hands and wrists.

SKILL LEVEL

Intermediate

YARN

Superfine (#1) weight.

Shown here: Cascade Heritage Silk (85% superwash merino wool, 15% mulberry silk; 437 yd [400 m]/100 g): #5663 Wine, 1 hank.

HOOKS

Size G/6 (4 mm).

Adjust hook size if necessary to obtain gauge.

NOTIONS

Yarn needle.

FINISHED DIMENSIONS

8½" long × 8" circumference (21.5 × 20.5 cm), plus ease.

GAUGE

21 sts and 15 rows = 4" (10 cm) in ribbing pattern (fpdc, bpdc).

SPECIAL STITCHES

Ribbing Using Front Post and Back Post, Wheat Cable

PATTERN NOTES

The wristers are worked in the round.

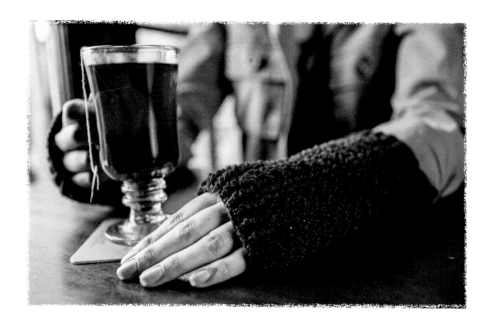

WRISTERS (Make 2)

Ch 38, being careful not to twist, join with slip st in first ch to form ring.

Rnd 1: Ch 2, dc in same st as join and in each ch across, slip st in first st to join. (38 sts, not including turning ch)

Rnd 2: Ch 2, [fpdc, bpdc] around, fpdc around turning ch, slip st in first st to join. (40 sts, including turning ch)

Rnd 3: Ch 2, [fpdc, bpdc] around, fpdc in last st, slip st in first st to join.

Rnd 4: (Wheat Cable) Ch 2, [sk 2 sts, fptr in next 2 sts, working behind last 2 sts, fptr in 2 skipped sts, sk 2 sts, fptr in next 2 sts, working in front of last 2 sts, fptr in 2 skipped sts, fpdc in next 2 sts] around to last st, fpdc around last st and turning ch, slip st in first st to join, turn. (41 sts)

Rnd 5: Ch 2, bpdc around, slip st in first st to join, turn.

Rnd 6: Ch 10 (for thumb hole), sk next 8 sts (cable), fpdc in next 2 sts, [sk 2 sts, fptr in next 2 sts, working behind last 2 sts, fptr in 2 skipped sts, sk 2 sts, fptr in next 2 sts, working in front of last 2 sts, fptr in 2 skipped sts, fpdc in next 2 sts] around, join with slip st to 3rd ch of ch loop, turn.

Rnd 7: Ch 2, bpdc around, 8 dc in ch-10 sp, slip st in first st to join, turn.

Rnds 8–27: Repeat Rnds 4 and 5 ten more times.

Rnd 28: Repeat Rnd 2. (42 sts)

Rnds 29–31: Repeat Row 3. Fasten off at the end of Rnd 31.

FINISHING

Weave in loose ends.

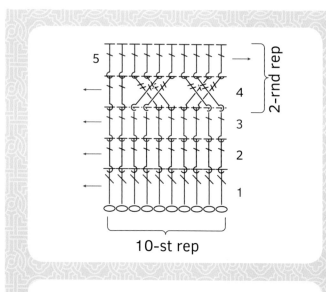

STITCH KEY

○ chain (ch)

⊤ double crochet (dc)

⨡ front post double crochet (fpdc)

⨡ back post double crochet (bpdc)

⨡ front post treble crochet (fptr)

⨡ back post treble crochet (bptr)

→ indicates direction of rows or rounds

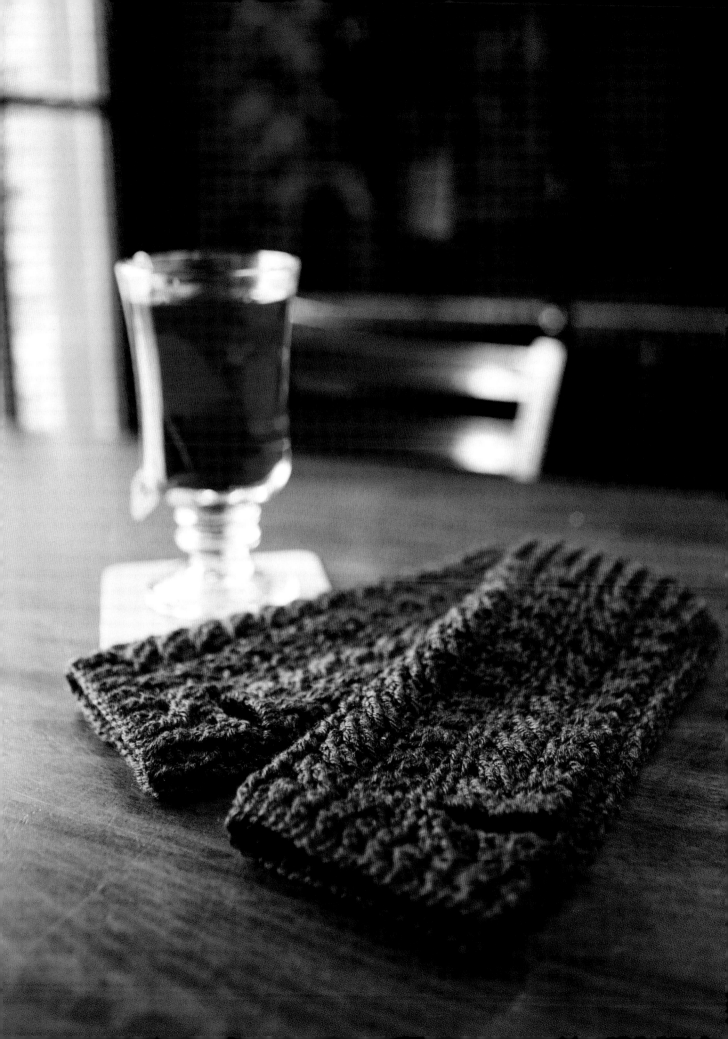

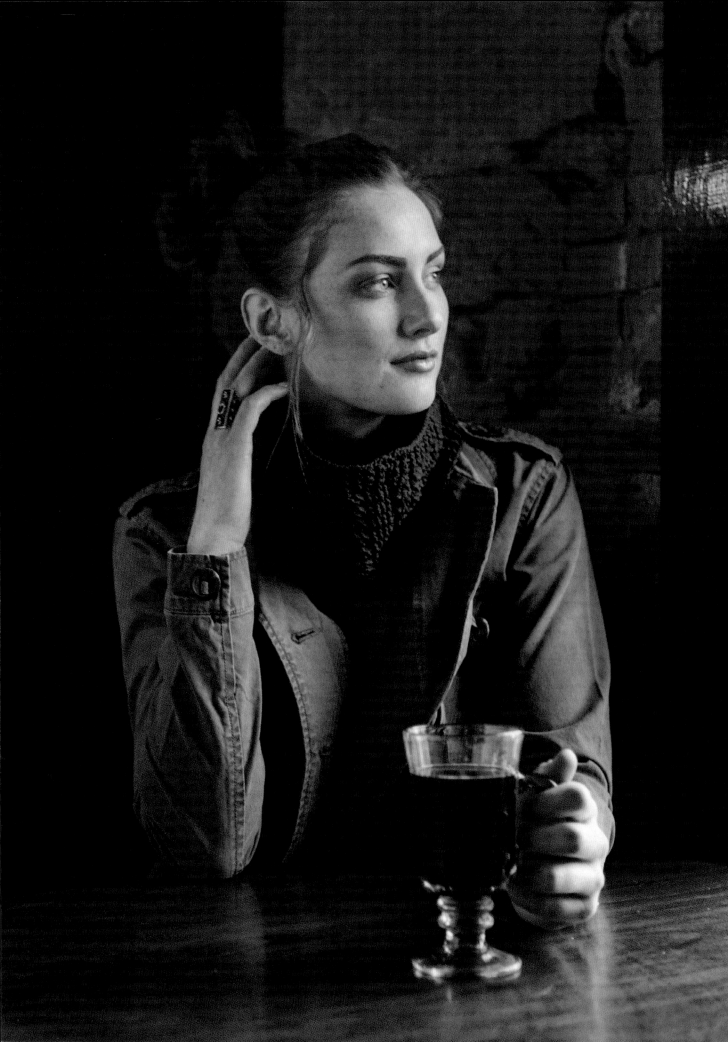

Silky and Chic Cowl

This cowl works up so quickly and beautifully, you'll want to make more in a variety of colors to match the rest of your winter wardrobe! Each cowl requires only one hank of yarn, so it is also an economical way to try a higher quality yarn. Don't worry about this cowl messing up your hair when you reach your destination—you'll want to wear this one all evening long!

SKILL LEVEL

Intermediate

YARN

Superfine (#1) weight.

Shown here: Cascade Heritage Silk (85% superwash merino wool, 15% mulberry silk; 437 yd [400 m]/100 g): #5655 Como Blue, 1 hank.

HOOKS

Size G/6 (4 mm).

Adjust hook size if necessary to obtain gauge.

NOTIONS

Yarn needle.

FINISHED DIMENSIONS

Approx. 24" circumference × 6" wide (61 × 15 cm).

GAUGE

21 sts and 15 rows = 4" (10 cm) in ribbing pattern (fpdc, bpdc).

SPECIAL STITCHES

Ribbing Using Front Post and Back Post, Wheat Cable

PATTERN NOTES

The cowl is worked in the round.

COWL

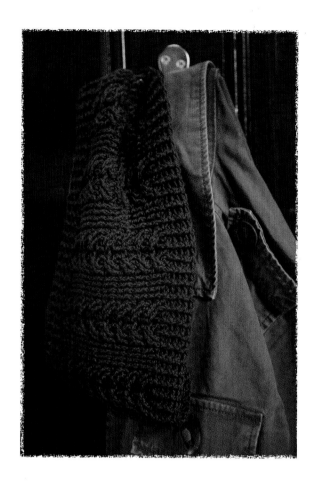

Ch 120, being careful not to twist, slip st in first ch to form ring.

Rnd 1: Ch 2, dc in same st as join and in each ch across (120 sts, not including turning ch). Slip st in first st of round to join.

Rnds 2–4: Ch 2, [fpdc, bpdc] around. Slip st in first st of round to join.

Rnd 5: Ch 2, [sk 2 sts, fptr in next 2 sts, working behind last 2 sts, fptr in 2 skipped sts, sk 2 sts, fptr in next 2 sts, working in front of last 2 sts, fptr in 2 skipped sts, fpdc in next 4 sts] around, turn, slip st in first st of round to join. (10 cables)

Rnd 6: Ch 2, bpdc around, slip st in first st of round to join, turn.

Rnds 7–20: Repeat Rnds 5 and 6 seven more times.

Rnds 21– 23: Repeat Rnd 2. Fasten off at the end of Row 23.

FINISHING

Weave in loose ends.

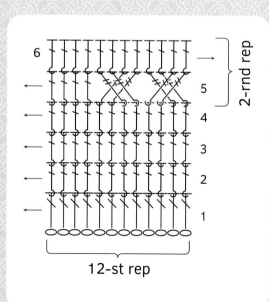

12-st rep

STITCH KEY

⬭ chain (ch)

╤ double crochet (dc)

front post double crochet (fpdc)

back post double crochet (bpdc)

front post treble crochet (fptr)

→ indicates direction of rows or rounds

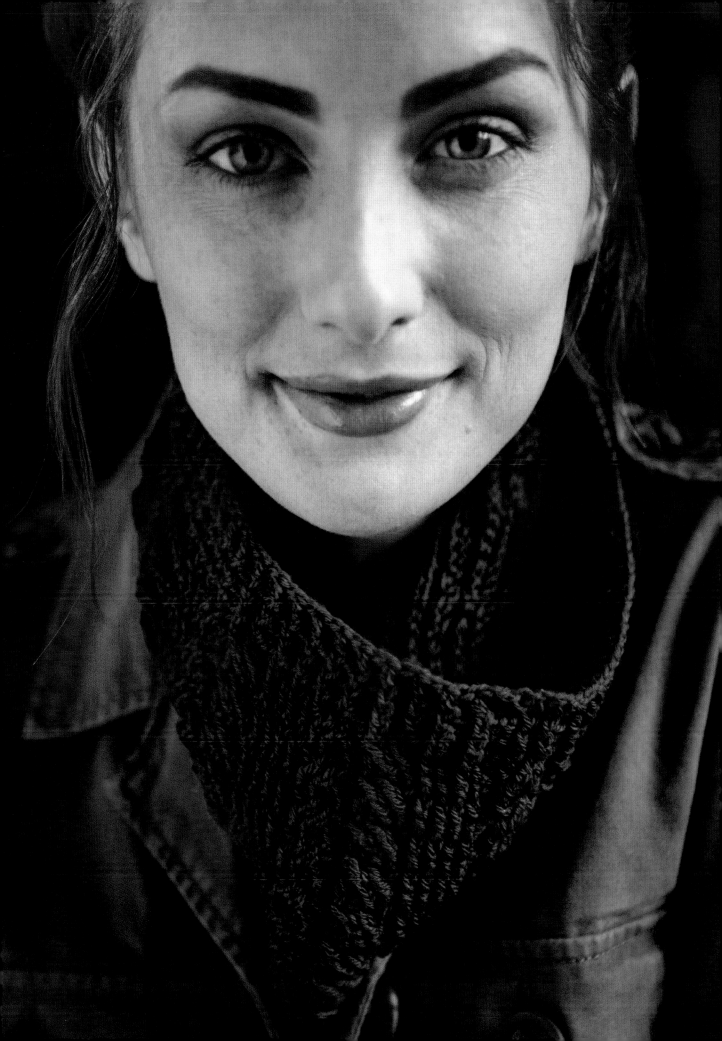

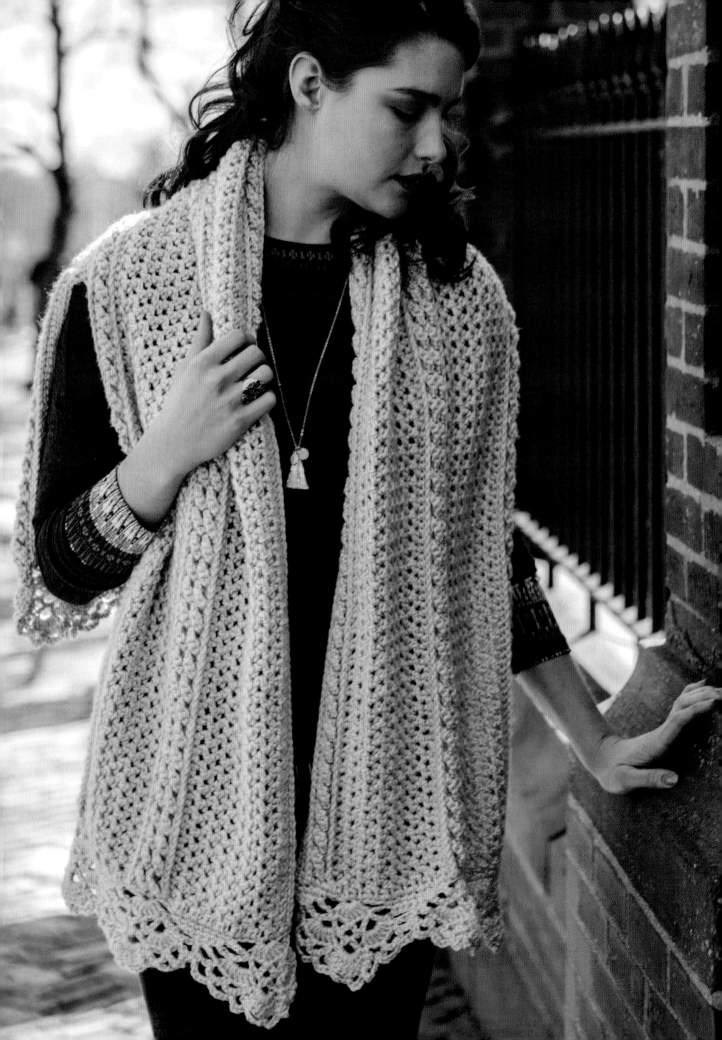

ARANMORE SWEATER WRAP

This style of wrap is an essential in the Barker house. I have found nothing better to ward off the chill in the air without being overheated by wearing a full sweater. I designed this model using simpler, understated cabling trimmed in bold lace. This is an excellent project for those who may be fearful of crocheting a fitted sweater, yet want to be able to enjoy their crochet projects beyond the typical scarf. The Aranmore Sweater Wrap offers a simple construction, and one size fits most.

SKILL LEVEL
Intermediate

YARN
Worsted (#4) weight.

Shown here: Lion Brand Heartland (100% acrylic; 251 yd (230 m)/142 g): #136-098 Acadia, 6 skeins.

HOOKS
Size J/10 (6 mm).

Adjust hook size if necessary to obtain gauge.
I/9 (5.5 mm).

NOTIONS
Yarn needle.

FINISHED DIMENSIONS
66½" × 34" (169 × 86.5 cm).

GAUGE
14 sts and 16 rows = 4" (10 cm) in sc.

SPECIAL STITCHES
Cable stitch, Low Front Ridge

Woven stitch (wv st)

Yo, insert hook into both loops of st, pull up a loop, pull hook through one loop on hook, yo, pull through both loops on hook (first half of wv st completed); yo, insert hook into same st, pull up a loop, pull through both loops on hook (second half of wv st completed).

STOLE SECTION

Ch 213.

Row 1: Sc in 2nd ch from hook and in each ch across. (212 sts)

Row 2: (Low Front Ridge) Ch 1, working in the front loop only, slip st in the next st and in each st across, slip st in the turning ch, turn.

Row 3: (Low Front Ridge) Ch 1, working in the unused loops from Row 1, sc in each sc across, do not work in the turning ch, turn.

Row 4: (Cable stitch) Ch 1, sc in first sc, *ch 3, sk next 2 unworked sc of previous row, sc in next sc, TURN and work sc in each ch of the ch-3 just made, slip st in the next sc (one cable made), TURN, working behind the cable, sc in each of the 2 skipped sc, sk sc that was made after the ch-3; repeat from * across to last sc, sc in last sc, turn.

Note: In the next row, you will work a sc in the first and last st, and 3 sc evenly spaced behind each cable (on wrong side). The 3 sc behind each cable are worked into the sc that was worked into the 2 skipped sc. Work sc in one of these skipped sc and 2 sc into the other. Do not work into the sc of the cables. Push the cables toward the right side of your project as you work.

Row 5: (WS, Cable stitch) Ch 1, sc in first sc, *2 sc in next sc, sc in next sc; repeat from * across to last sc, sc in last sc, turn.

Rows 6 and 7: Repeat Rows 2 and 3.

Row 8: (Woven stitch) Ch 2, sk first st, work first wv st (see Special Stitches) in 2nd st, sk next sc, wv st in next st; repeat across row, working in every other st, ending with wv st in last st. (106 wv sts)

Rows 9–22: Ch 2, wv st between first and 2nd wv sts of previous row, continue across row, being careful to work in sps between wv sts, ending with last wv st in ch-2 sp of previous row.

Row 23: (Row to discontinue wv sts) Ch 2, 2 sc in each space between wv sts across and last ch-2 sp. (212 sts)

Rows 24 and 25: Repeat Rows 2 and 3.

Rows 26–29: Repeat Rows 4 and 5 twice.

Rows 30 and 31: Repeat Rows 2 and 3.

Rows 32–47: Repeat Rows 8–23.

Rows 48–53: Repeat Rows 2–7.

Perimeter rnd of Stole: Ch 1, turn, *sc in each st across to corner, ch 2, rotate piece 90 degrees, work 48 sc evenly along row ends, ch 2, rotate piece 90 degrees; repeat from * to first st of round, join with slip st to first sc of rnd. Fasten off.

BACK SECTION

Ch 45.

Row 1: Sc in 2nd ch from hook and in each ch across. (44 sts)

Rows 2–8: Rep Rows 2–8 as for Stole over 44 sts. (22 wv sts)

Rows 9–34: Ch 2, wv st between first and 2nd wv sts of previous row, continue across row, being careful to work in sps between wv sts, ending with last wv st in ch-2 sp of previous row.

Row 35: (Row to discontinue wv sts) Ch 2, 2 sc in each space between wv sts across and last ch-2 sp. (44 sts)

Rows 36–43: Repeat Rows 24–31 of Stole instructions.

Rows 44–71: Repeat Rows 8–35 of Back instructions.

Rows 72–77: Repeat Rows 2–7 of Back instructions. Continue to Perimeter rnd.

Perimeter rnd of Back: Ch 1, turn, *sc in each st across to corner, ch 2, rotate work 90 degrees, work 67 sc evenly along row ends, ch 2, rotate work 90 degrees; repeat from * to first st, join with slip st in first sc of rnd. Fasten off.

JOINING BACK TO STOLE

With RS together, center Back Section on Stole Section with 72 sts on either side, working through both thicknesses, slip st in perimeter sc sts across to seam.

LACE TRIM

Add lace trim to ends of Stole and Back Sections. Instructions for Back Section in parentheses where necessary. *Change to smaller hook (size I/9).*

Row 1: With RS facing, join with slip st to Stole end (or Back Section) at ch-2 corner, sc in same sp as joining and in next 4 sts, [ch 3, sk 3 sts, 7 dc in next sp, ch 3, sk 4 sts, sc in next 9 sts] 3 (4) times, sk 3 sts, ch 3, 7 dc in next st, sk 3 sts, ch 3, sc in last 5 sts, turn. (3 [4] motif repeats)

Row 2: Ch 1, sc in first 4 sc, *ch 3, (dc, ch 3, dc) in next dc, [sk 2 dc, dc, ch 3, dc in next dc] twice, ch 3, sk 1 sc, sc in next 7 sc; repeat from * across, ending with ch 3, sc in last 4 sc, turn.

Row 3: Ch 1, sc in first 2 sc, *ch 3, 7 dc in between next 2 dc, (dc, ch 3, dc) in next ch-3 sp, 7 dc in next ch-3 sp, ch 3, sk 2 sc, sc in next 3 sc; repeat from * across, ending with ch 3, sc in last 2 sc, turn.

Row 4: Ch 1, sc in first sc, ★ch 3, sc in next dc, [ch 5, sk 2 dc, sc in next dc] twice, ch 3, 7 dc in ch–3 sp, ch 3, sc in dc [ch 5, sk 2 dc, sc in next dc] twice, ch 3, sk next sc, sc in next sc, repeat from ★ across, ending with ch 3, sc in last sc, turn.

Row 5: Slip st in next loop, ch 1, sc in same loop, ★[ch 5, sc in next loop] twice, ch 5, sc in next dc, [ch 5, sk 2 dc, sc in next dc] twice, [ch 5, sc in next ch–5 loop] twice, sc in next 2 loops; repeat from ★ across, ending with ch 5, slip st in last sc. Fasten off.

FINISHING

Weave in loose ends.

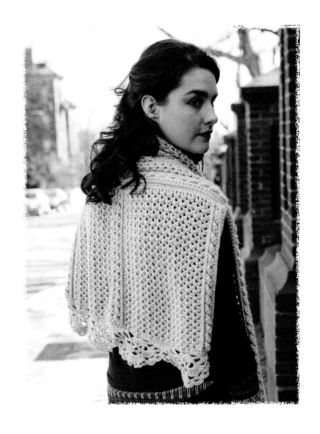

STOLE

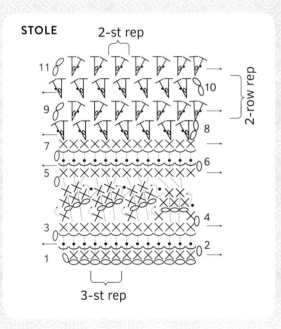

STITCH KEY

•	slip st		woven stitch
◯	chain (ch)	indicates when stitches are worked in lower rows
‿	work in front loop only	→	indicates direction of rows or rounds
✕	single crochet (sc)	↰	indicates specific insertion points or mid-row turn
⊤	double crochet (dc)		

LACE TRIM

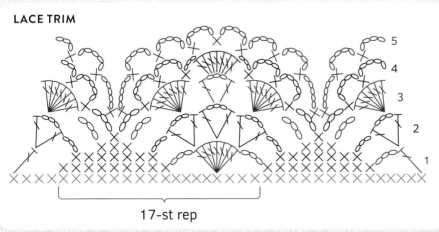

17-st rep

ONE BIG BRAID SCARF

This wrap-around scarf works up quickly and is an excellent way to learn how to crochet the large braided cable. The One Big Braid Scarf can be worn any number of ways: as a long scarf, as a wraparound, or as a buttoned cowl. When shopping for yarn, don't forget to pick up an amazing oversized button to complement your One Big Braid!

SKILL LEVEL
Confident Beginner to Intermediate

YARN
Super Bulky (#6) weight.

Shown here: Lion Brand Heartland Thick & Quick (100% acrylic; 125 yd [114 m]/142 g): #137-135 Yosemite, 3 skeins.

HOOKS
Size P/16 (11.5 mm).

Adjust hook size if necessary to obtain gauge.

NOTIONS
Yarn needle.

1 large button, approx. 2½" (6.5 cm) in diameter.

FINISHED DIMENSIONS
61" × 4" (155 × 10 cm).

GAUGE
9 sts = 4" (10 cm), 4 rows = 2" (5 cm) in sc.

SPECIAL STITCHES
Big Braided Cable, Buttonhole

SCARF

Ch 13.

Row 1: Dc in 4th ch and in each ch across, turn. (10 sts, not including turning ch)

Row 2: (RS) Ch 2, fpdc in next st and in each st across, hdc in turning ch, turn. (11 sts)

Row 3: Ch 2, bpdc in each st across, hdc in turning ch, turn.

Row 4: Ch 3, sk 4 sts, fptr in next 3 sts, working in front of last 3 sts, fptr in last 3 skipped sts, fptr in next 3 sts, dc in turning ch, turn.

Row 5: Ch 3, sk 4 sts, bptr in next 3 sts, working behind last 3 sts (will cross on RS), bptr in last 3 skipped sts, bptr in next 3 sts, dc in turning ch, turn.

Rows 6–49: Repeat Rows 4 and 5 twenty-two more times more.

Row 50: Repeat Row 4.

Row 51: Ch 2, bpdc across row, turn.

Row 52: Ch 1, sc across, sc in turning ch, turn.

Row 53: Sk first st, sc in next 3 sts, ch 3, sk 3 sts (for buttonhole), sc in next 3 sts and in turning ch, turn.

Row 54: Sk first st, sc in next 3 sts, 3 sc in ch–3 sp, sc in next 3 sts and in turning ch, turn.

Rows 55 and 56: Sk first st, sc across, sc in turning ch. Fasten off at the end of Row 56.

FINISHING

Weave in loose ends.

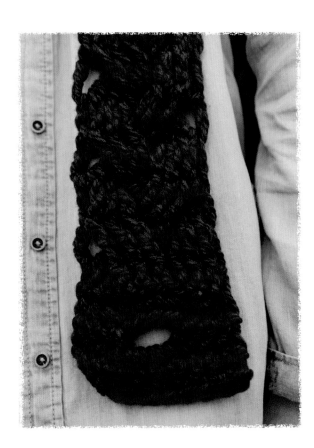

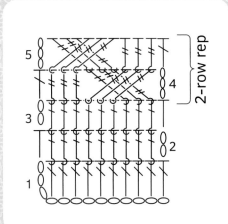

STITCH KEY

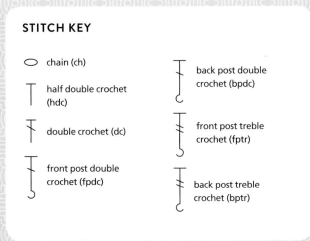

- ⬭ chain (ch)
- ⊤ half double crochet (hdc)
- ⊤ double crochet (dc)
- ⊤ front post double crochet (fpdc)
- ⊤ back post double crochet (bpdc)
- ⊤ front post treble crochet (fptr)
- ⊤ back post treble crochet (bptr)

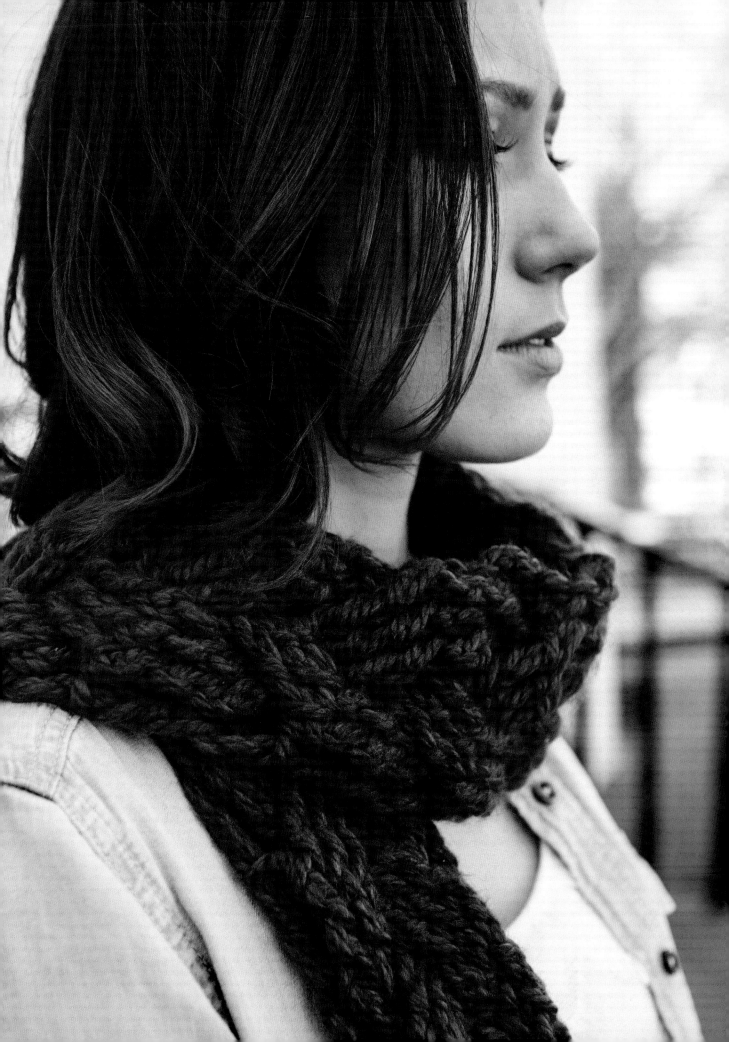

TIC-TAC-TOE MESSENGER BAG

This big, beautiful crocheted bag is the perfect size for your special books, small yarn project, or even a quick trip out to the store. While crocheting, just be sure you pay close attention to the Tic-Tac-Toe pattern and all will (hopefully) go well. Make the strap as long as you need, and line it with beautiful cotton fabric for strength. Top it off with an amazing button, and you're ready to go!

SKILL LEVEL
Intermediate

YARN
Worsted (#4) weight.

Shown here: Ella Rae Phoenix (100% Egyptian cotton; 182 yd [166 m]/100g): #42 Copper Canyon, 5 hanks.

HOOKS
Size I/9 (5.5 mm).

Adjust hook size if necessary to obtain gauge.

Size H/8 (5 mm) or one size smaller than gauge hook.

NOTIONS
I/9 (5.5 mm) crochet hook or size needed for gauge.

½ yd (45.5 cm) matching cotton fabric for lining inside of bag and strap.

FINISHED DIMENSIONS
13" tall × 12" wide (33 × 30.5 cm); strap approx. 37" × 1¾" (94 × 4.5 cm).

GAUGE
16 sts and 8 rows = 4" (10 cm) in dc.

SPECIAL STITCHES
Celtic Weave, Four-Stitch Post Cable

PATTERN NOTES
Turning chain is not counted as a stitch in the stitch count. At the end of each round, join with a slip st to the top of the first st. Ch 2 at the beginning of each round. Even-numbered rounds will have the front side facing.

A word about the post stitches in this pattern: Please be careful to note that fpdc, bpdc, fptr, and bptr stitches are used in the same rounds/rows!

I recommend sewing the fabric lining after completing the crocheted bag so that it can be better customized.

BAG

Using larger hook, ch 52.

Rnd 1: *Note: This round will be worked on BOTH sides of the foundation chain.* Dc in the 3rd ch from hook and in each ch across to last ch, work 4 dc in last ch, rotate 180 degrees to continue on the opposite side of the foundation ch, dc in each ch across to last st, work 3 dcs in last ch, slip st to join in top of first st of rnd, do not turn. (100 sts)

Rnd 2: Ch 2, *[sk 2 sts, fptr in next 2 sts, working in front of last 2 sts, fptr in skipped sts] 12 times, 2 fpdc; repeat from * once more, slip st to join in first st of rnd, turn.

Rnd 3: Ch 2, *2 bpdc, 16 bpdc, (Celtic Weave) 2 bptr [sk 2 sts, bptr in next 2 sts, working behind last 2 sts (will appear crossed on front side), bptr in 2 skipped sts] 3 times, 2 bptr, 16 bpdc; repeat from * once more, slip st to join in turning ch, turn.

Rnds 4–9: Repeat Rnds 2 and 3 three more times.

Rnd 10: Repeat Rnd 2.

Rnd 11: Ch 2, *2 bpdc, [sk 2 sts, bptr in next 2 sts, working behind last 2 sts, bptr in 2 skipped sts] 4 times, 16 bpdc, 2 bptr, [sk 2 sts, bptr in next 2 sts, working behind last 2 sts, bptr in 2 skipped sts] 3 times, 2 bptr; repeat from * once more.

Rnds 12–17: Repeat Rnds 10 and 11 three more times.

Rnds 18–25: Repeat Rnds 2 and 3 four more times.

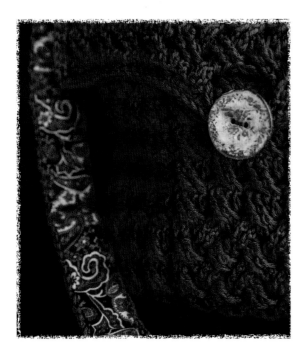

FLAP

Row 26: Continuing from Rnd 25, ch 2, [sk 2 sts, fptr in next 2 sts, working in front of last 2 sts, fptr in skipped sts] 12 times, dc in sp between last st and next st, turn, leaving rem sts unworked. (49 sts)

Row 27: Ch 2, 16 bpdc, 2 bptr, [sk 2 sts, bptr in next 2 sts, working behind last 2 sts, bptr in 2 skipped sts] three times, 2 bptr, 16 bpdc, dc in turning ch, turn.

Row 28: Ch 2, [sk 2 sts, fptr in next 2 sts, working in front of last 2 sts, fptr in skipped sts] 12 times, dc in turning ch.

Row 29: Rep Row 27.

Rows 30–35: Repeat Rows 28 and 29 three more times.

Row 36: Repeat Row 28 once more.

Row 37: (Buttonhole row) Ch 2, 16 bpdc, 2 bptr, sk next 2 sts, bptr in next 2 sts, working behind last 2 sts, bptr in 2 skipped sts] once, ch 6, sk 6 sts, bptr in next 2 sts, working in front of last 2 sts, bptr in 2 skipped sts (closest to last 2 just worked), bptr in next 2 sts, 16 bpdc, dc in turning ch.

Change to smaller hook.

Rnd 38: Ch 1, sc in each st across end of flap, [work (sc, ch 1, sc) in corners], down side of flap, across opening of bag, and up other edge of flap, slip st to join in first sc. Do not turn.

Rnd 39: Ch 1, slip st in each st around flap and opening of bag, slip st to join in first slip st. Finish off.

STRAP

Using larger hook, ch 9.

Row 1: Dc in 3rd ch from hook and in each ch, turn. (7 sts)

Row 2: Ch 2, fpdc, skip 2 sts, fptr in next 2 sts, working in front of last 2 sts, fptr in 2 skipped sts, fpdc, dc in turning ch, turn.

Row 3: Ch 2, 6 bpdc, dc in turning ch, turn.

Rows 4–75: Repeat Rows 2 and 3 thirty-five more times or until strap reaches desired length. Finish off at the end of last row.

FINISHING

Weave in loose ends.

It is best to attach the lining to the bag and strap before assembling the bag. For bag lining, measure bag and flap

and cut fabric to that size plus ¼" (6 mm) on all sides for seam allowance. Fold the fabric right sides facing and sew sides of the bag portion, leaving the flap unsewn. Fold all edges under ½" (1.3 cm), wrong sides facing, and hand stitch to the bag interior.

For the strap, cut the fabric to ¼" (6 mm) larger than the crocheted strap on all sides. Fold the edges under ½" (1.3 cm), wrong sides facing. Hand stitch the lining to the strap, centering the fabric to leave ¼" of the crocheted strap unlined on all edges. Attach strap to the inside of the bag using a whipstitch and matching thread. Sew the strap ends approx. ½" below the top edge, making sure to work through both the fabric and yarn layers.

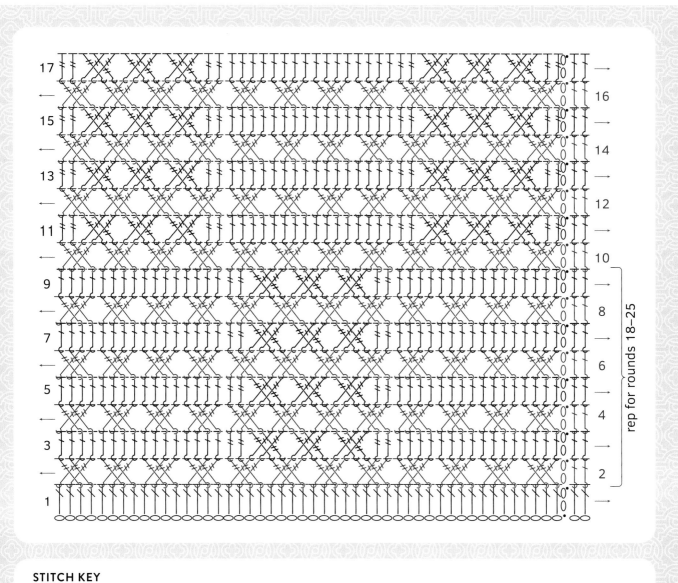

STITCH KEY

- • slip st
- ⬭ chain (ch)
- ⊤ double crochet (dc)
- front post double crochet (fpdc)
- back post double crochet (bpdc)
- front post treble crochet (fptr)
- back post treble crochet (bptr)
- → indicates direction of rows or rounds

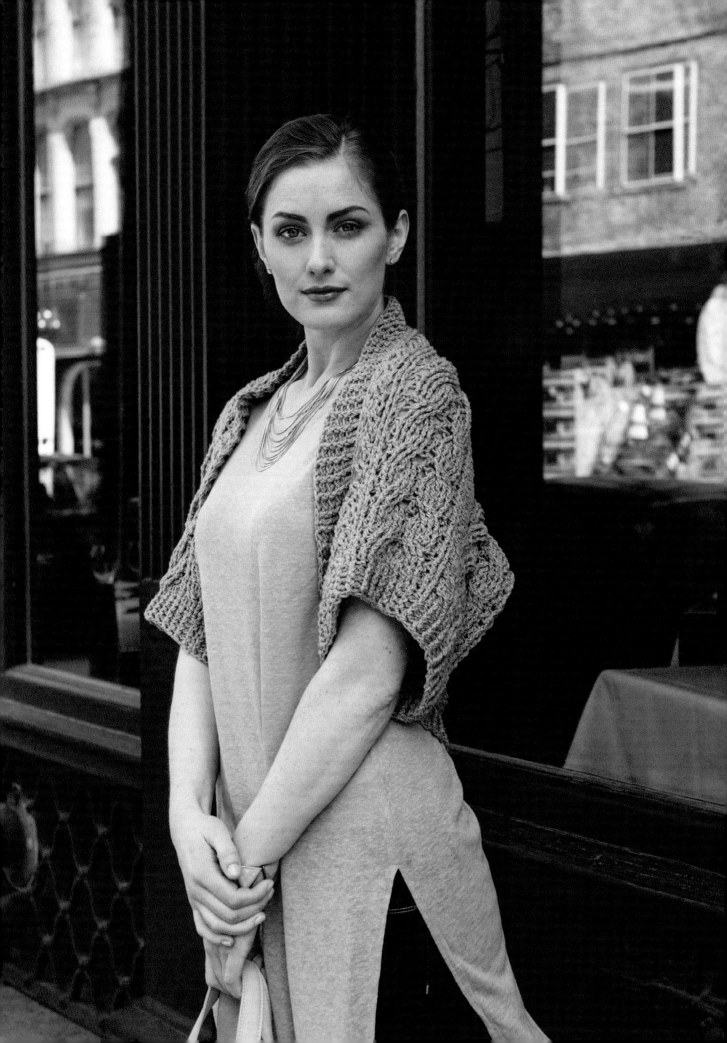

FERGUS SHRUG

If you've never crocheted a garment before, this is a wonderful place
to start. This design embodies a simple construction and only
two short seams to crochet together.

SKILL LEVEL
Intermediate

YARN
DK (#3) weight.

Shown here: Cestari Montpelier Collection
(67% cotton, 25% wool, 8% silk; 230 yds
[210 m]/100 g): #177008 Palm Tree,
5 [5, 5, 5, 6, 7, 7] skeins.

HOOKS
Size H/8 (5 mm).

Adjust hook size if necessary to obtain gauge.

NOTIONS
Yarn needle.

SIZES/ FINISHED DIMENSIONS
XS (S, M, L, XL, 2X, 3X). See schematics for
specific measurements.

GAUGE
15 sts = 4" (10 cm), 3 rows = 1" (2.5 cm) in
ribbing pattern (fpdc, bpdc).

SPECIAL STITCHES

Four-Stitch Cable

Row 1: Sk next 2 sts, fptr in next 2 sts, working
in front of last 2 sts, fptr in skipped sts.

Row 2: Bpdc in next 4 sts.

Row 3: Repeat Row 1.

Row 4: Repeat Row 2.

Large Wheat Cable

Row 1: Hdc, sk 3 sts, hdc, 3 fptr, working
behind last 3 skipped sts and hdc, fptr in first
3 skipped sts, hdc in next st along row, sk
3 sts, hdc, 3 fptr, working in front of last
3 skipped sts, fptr in 3 skipped sts, hdc.

Row 2: Hdc, [3 bpdc, hdc between last st and
next st (at center of cable), 3 bpdc, sk next
hdc, hdc in next hdc] twice.

Row 3: Hdc, [3 fpdc, hdc] 4 times.

Row 4: Hdc, [3 bpdc, hdc] 4 times.

PATTERN NOTES
Ch 2 at the beginning of each row, turn at
the end of each row.

Turning chain does not count as a stitch in the
stitch count.

Pattern contains fpdc, fptr, bpdc, and bptr.
Be very careful to follow pattern accordingly.

Hdc are not post stitches and are worked in
the normal fashion of inserting the hook into
the top loops of the stitch.

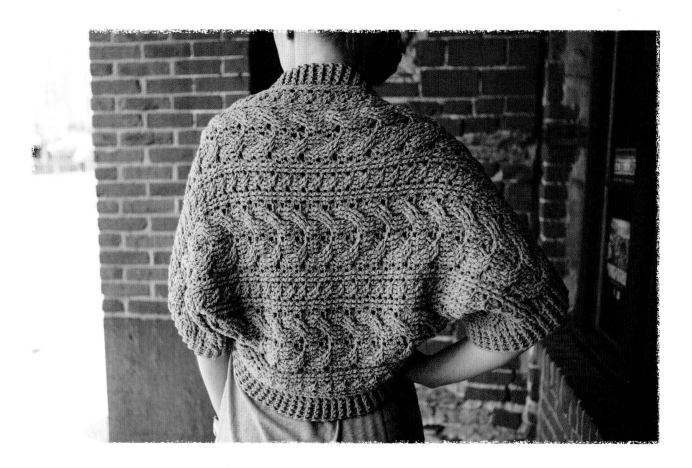

SHRUG

Ch 74 (74, 86, 86, 86, 102, 102).

Set-up row to Row 4 are written according to the size you are making. The general directions continue with Row 5.

Sizes XS and S only

Set-up row: Dc in 3rd ch from hook and in each ch across. (72 sts, not including turning ch)

Row 1: Ch 2, starting in next st, ★work [2 fpdc, work Row 1 of Large Wheat Cable, 2 fpdc★★, work Row 1 of 4–St Cable] twice, then repeat from ★ to ★★ once more, hdc in turning ch, turn.

Row 2: Ch 2, ★work [2 bpdc, work Row 2 of Large Wheat Cable, 2 bpdc★★, work Row 2 of 4–St Cable] twice, then repeat from ★ to ★★ once more, hdc in turning ch, turn.

Row 3: Ch 2, ★work [2 fpdc, work Row 3 of Large Wheat Cable, 2 fpdc★★, work Row 3 of 4–St Cable] twice, then repeat from ★ to ★★ once more, hdc in turning ch, turn.

Row 4: Ch 2, ★work [2 bpdc, work Row 4 of Large Wheat Cable, 2 bpdc★★, work Row 4 of 4–St Cable] twice, then repeat from ★ to ★★ once more, hdc in turning ch, turn.

Sizes M, L, and XL only

Set-up row: Dc in 3rd ch from hook and in each ch across. (84 sts, not including turning ch)

Row 1: Ch 2, starting in next st, 2 fpdc, work Row 1 of 4–St Cable, 2 fpdc, [work Row 1 of Large Wheat Cable, 2 fpdc, work Row 1 of 4–St Cable, 2 fpdc] 3 times, hdc in turning ch.

Row 2: Ch 2, 2 bpdc, work Row 2 of 4-St Cable, 2 bpdc, [work Row 2 of Large Wheat Cable, 2 bpdc, work Row 2 of 4-St Cable, 2 fpdc] 3 times, hdc in turning ch.

Row 3: Ch 2, 2 fpdc, work Row 3 of 4-St Cable, 2 fpdc, [work Row 3 of Large Wheat Cable, 2 fpdc, work Row 3 of 4-St Cable, 2 fpdc] 3 times, hdc in turning ch.

Row 4: Ch 2, 2 bpdc, work Row 4 of 4-St Cable, 2 bpdc, [work Row 4 of Large Wheat Cable, 2 bpdc, work Row 4 of 4-St Cable, 2 bpdc] 3 times, hdc in turning ch.

Sizes 2X and 3X only

Sizing Note: This design will feature two 4-St Cables (instead of one as in the model shown in photos) for these sizes.

Set-up row: Dc in 3rd ch from hook and in each ch across. (100 sts, not including turning ch)

Row 1: Ch 1, starting in next st, [2 fpdc, (work Row 1 of 4-St Cable) twice, 2 fpdc, work Row 1 of Large Wheat Cable] 3 times, ending with 2 fpdc, [work Row 1 of 4-St Cable] twice, 2 fpdc, hdc in turning ch.

Row 2: Ch 1, [2 bpdc, (work Row 2 of 4-St Cable) twice, 2 bpdc, work Row 2 of Large Wheat Cable] 3 times, ending with 2 bpdc, [work Row 2 of 4-St Cable] twice, 2 bpdc, hdc in turning ch.

Row 3: Ch 1, [2 fpdc, (work Row 3 of 4-St Cable) twice, 2 fpdc, work Row 3 of Large Wheat Cable]

3 times, ending with 2 fpdc, [work Row 3 of 4-St Cable] twice, 2 fpdc, hdc in turning ch.

Row 4: Ch 1, [2 bpdc, (work Row 4 of 4-St Cable) twice, 2 bpdc, work Row 4 of Large Wheat Cable] 3 times, ending with 2 bpdc, [work Row 4 of 4-St Cable] twice, 2 bpdc, hdc in turning ch.

All Sizes

Rows 5–56 (60, 64, 68, 72, 78, 78): Repeat Rows 1–4 a total of 13 (14, 15, 16, 17, 18, 18) more times.

Next 3 rows: Repeat Rows 1–3 once more. Do not fasten off, but continue to Sleeves section. Piece should have dimensions shown on schematic.

SLEEVES

With RS together, fold along length to make a tube. (See diagram.) Continuing from last row worked, slip st both pieces together along edge for 12 rows (or approx. 4½" [11.5 cm]). Fasten off. Join with a slip st to other end for other sleeve. Slip st both pieces together and continue along edge for 12 rows (or approx. 4½"). Fasten off. Turn right side out.

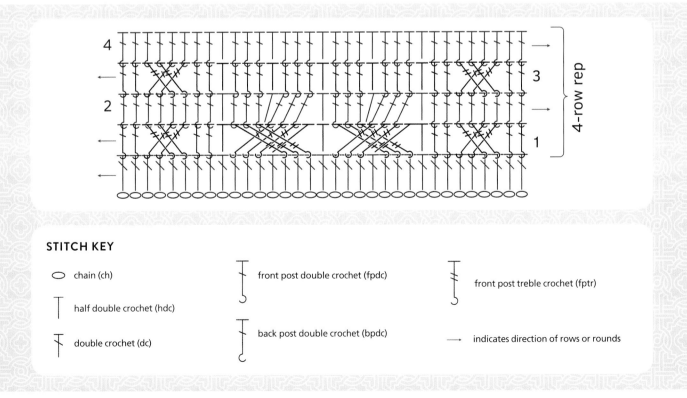

STITCH KEY

⬭ chain (ch)

T half double crochet (hdc)

Ŧ double crochet (dc)

Ŧ front post double crochet (fpdc)

Ŧ back post double crochet (bpdc)

Ŧ front post treble crochet (fptr)

→ indicates direction of rows or rounds

SLEEVE RIBBING (for both sleeves)

Rnd 1: With RS facing, join with a slip st to sleeve seam on outer edge. Ch 2, fpdc around each dc and tr, skip each hdc around. (This will decrease the number of stitches from the pattern rows, thereby making the sleeve narrower.) Join with a slip st to the first st of rnd. Do not turn at the end of row. (60 [60, 69, 69, 69, 81, 81] sts)

Rnds 2–5: Ch 2, [fpdc, bpdc] around. Join with a slip st to the first st of rnd. Do not turn. Finish off at the end of Rnd 5.

BODY OPENING
FINISHING AND RIBBING

Rnd 1: With RS facing, join with a slip st at sleeve seam on inside section. Ch 2, dc in same row end as joining. Work 2 dcs in each row evenly around opening of shrug. Join with a slip st to the first st of round.

Rnds 2–5: Ch 2, [fpdc, bpdc] around, fpdc in last st. Join with a slip st to the first st of rnd. Do not turn. Finish off at the end of Rnd 5.

FINISHING

Weave in loose ends.

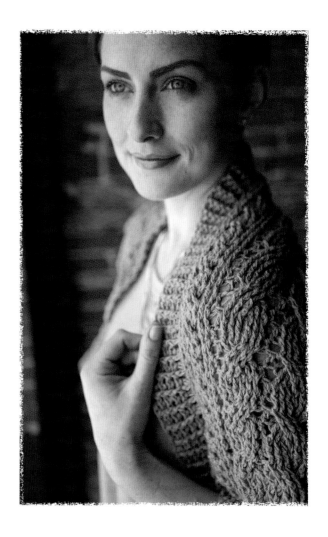

5 (5½, 5½, 6, 6, 7, 7)"
12.5 (14, 14, 15, 15, 18, 18) cm

shrug

31 (32, 33½, 35, 36½, 37, 37)"
79 (81.5, 85, 89, 92.5, 94, 94) cm

14 (14, 17, 17, 17, 21, 21)"
35.5 (35.5, 43, 43, 43, 53.5, 53.5) cm

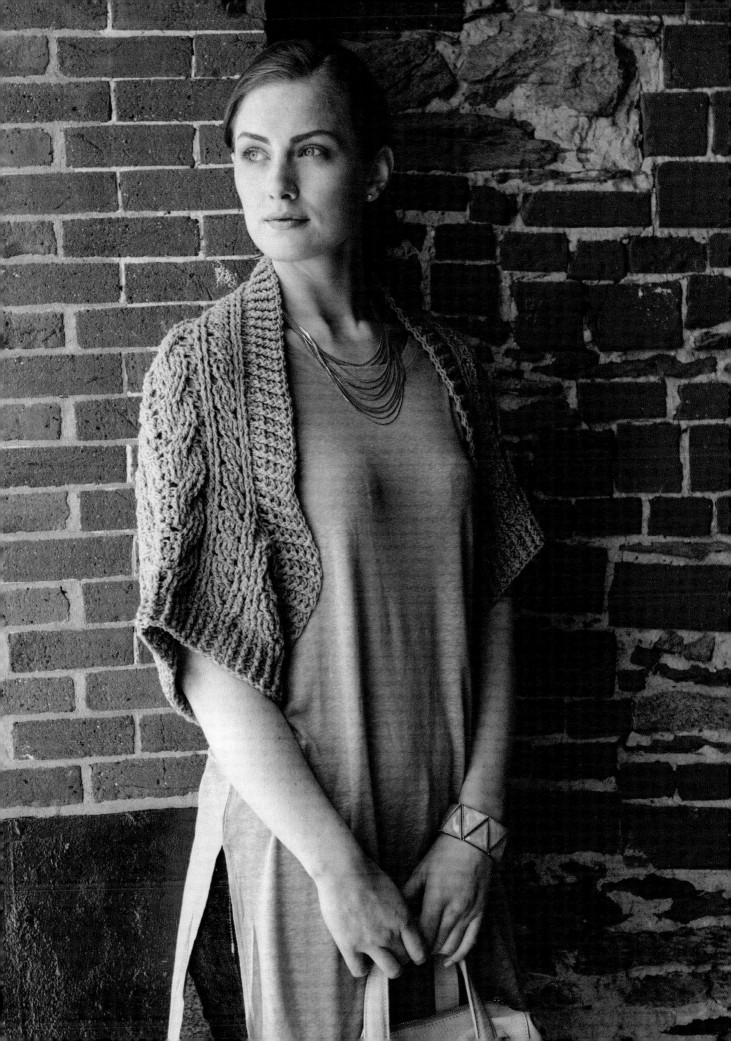

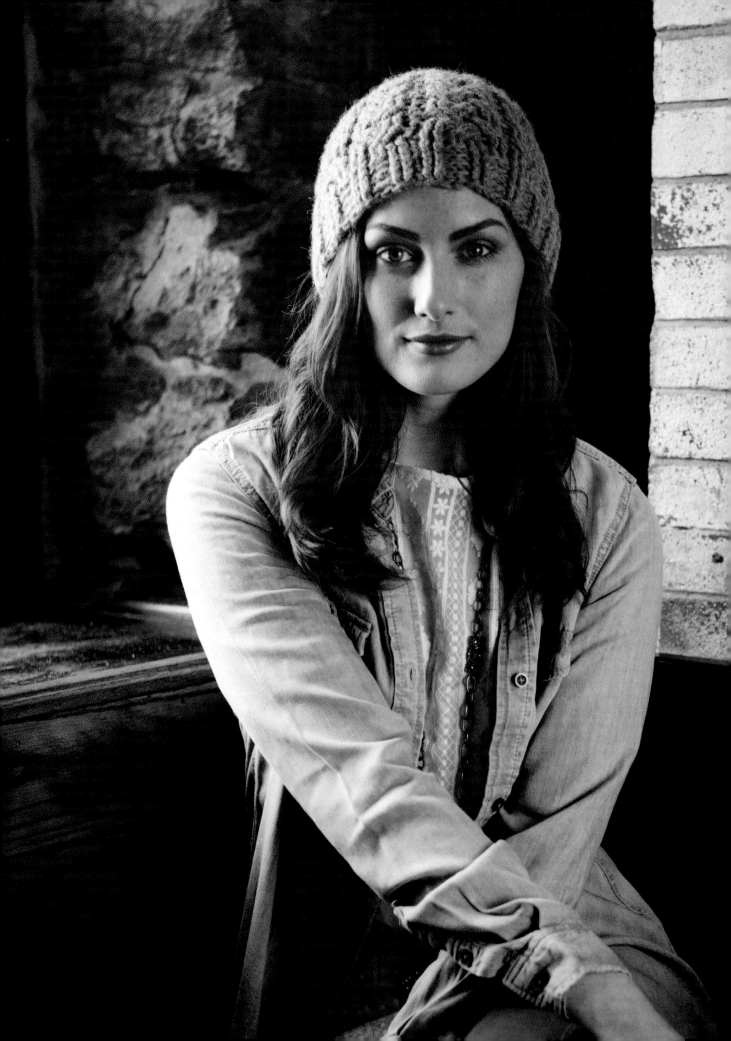

Braids and Weaves Alpaca Hat

This is my personal go-to hat when the winter comes. I just love the feel of alpaca, especially when adding my favorite Celtic Weave stitch to the mix. This stitch is a bit more challenging but worth the effort. Be sure to check out my free online video tutorials should you ever need more than photos to learn these cabling techniques. No one should have to miss out on the fun and beauty of crocheting cables!

SKILL LEVEL
Intermediate

YARN
DK (#3) weight.

Shown here: Juniper Moon Farm Herriot (100% alpaca; 218 yd [200 m]/100 g): #08 Sycamore, 1 hank.

HOOKS
Size J/10 (6 mm).

Adjust hook size if necessary to obtain gauge.

NOTIONS
Yarn needle.

FINISHED DIMENSIONS
7¼" (18.5 cm) from top of crown to brim, 22" (56 cm) circumference.

GAUGE
13 sts = 4" (10 cm), 3 rows = 1" (2.5 cm) in ribbing pattern (2 fpdc, 2 bpdc).

SPECIAL STITCHES
Braided Cable, Celtic Weave, Ribbing Using Front Post and Back Post

HAT

Ch 4, join with a slip st to the first ch to form a ring.

Rnd 1: Ch 1, 9 sc in ring, slip st in first st to join. (9 sts)

Rnd 2: Ch 1, 2 sc in each st around, slip st in first st to join. (18 sts)

Rnd 3: Ch 1, 2 sc in each st around, slip st in first st to join. (36 sts)

Rnd 4: Ch 2, dc in same st as joining, 2 dc in each st to last st, 1 dc in last st, slip st in first st of rnd to join. (70 sts)

Rnd 5: (RS) Ch 2, ★[sk 2 sts, fptr in next 2 sts, working in front of last 2 sts, fptr in 2 skipped sts] 2 times, sk 2 sts, fptr in next 2 sts, working in front of last 2 sts, fptr in 2 skipped sts, fptr in next 2 sts (braid made); repeat from ★ around, slip st to join in first st of rnd, turn.

Rnd 6: (WS) Ch 2, ★sk 2 sts, bptr in next 2 sts, working behind last 2 sts (will cross in front on RS) bptr in 2 skipped sts, bptr in next 2 sts (braid made), bptr in next 2 sts, sk next 2 sts, bptr in next 2 sts, working behind last 2 sts, bptr in 2 skipped sts, bptr in next 2 sts; repeat from ★ around, slip st to join in first st of rnd, turn.

Rnds 7–14: Repeat Rnds 5 and 6 four more times.

Rnd 15: (RS) Ch 2, [fpdc in next 2 sts, bpdc in next 2 sts] around to last 2 sts, fpdc in last 2 sts, slip st to join in first st of rnd, do not turn.

Rnds 16–19: Repeat Rnd 15. Finish off at the end of Rnd 19.

FINISHING

Weave in loose ends.

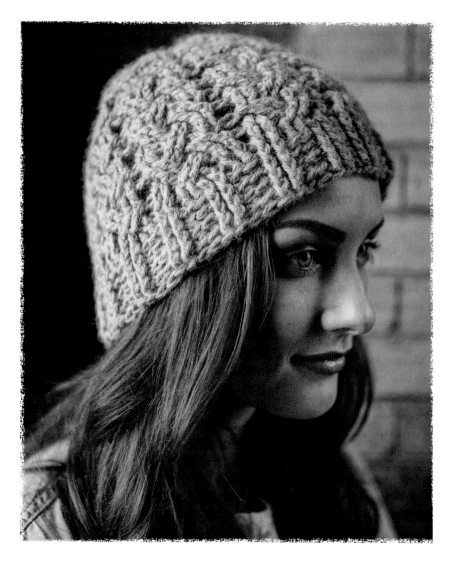

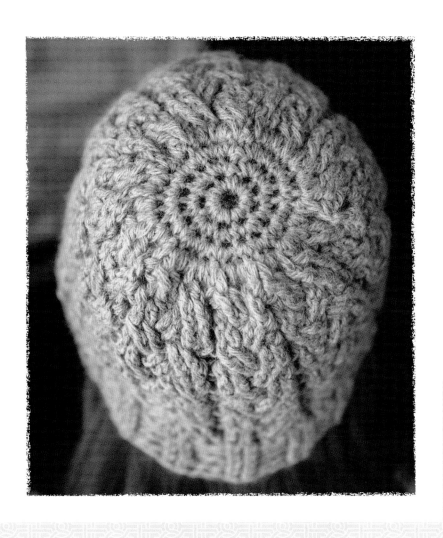

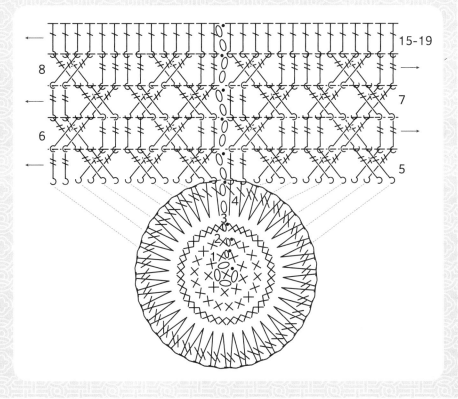

STITCH KEY

- • slip st
- ◯ chain (ch)
- ✕ single crochet (sc)
- ┬ double crochet (dc)
- ┬ front post double crochet (fpdc)
- ┬ back post double crochet (bpdc)
- ╫ front post treble crochet (fptr)
- ╫ back post treble crochet (bptr)
- → indicates direction of rows or rounds

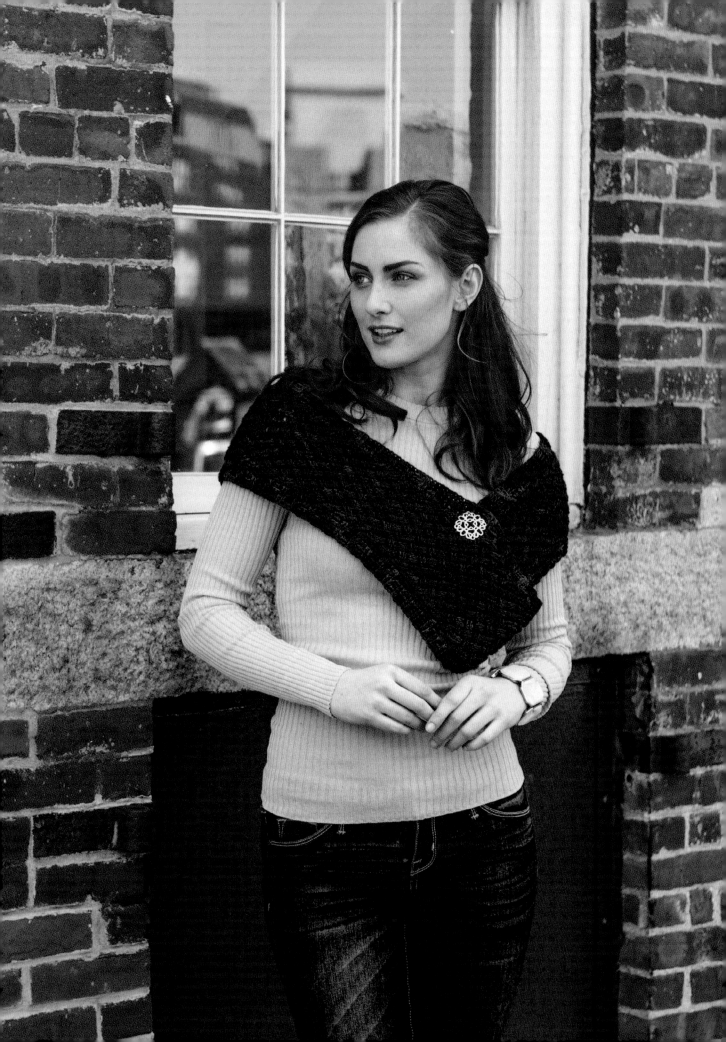

Emerald Celtic Weave Infinity Scarf

This is by far the most lavish yarn I have had the privilege to use! Save this project for that extremely special person in your life whom you want to bless with a gift that keeps on giving year after year. This is another simpler design that can be worn a number of ways, each just as lovely as the next. Add a brooch or shawl pin and wear over your shoulders, or simply double and wear as a cowl—the choice is yours! You just may find yourself saying, "Ah…" in a contented way while crocheting and/or wearing this one!

SKILL LEVEL
Intermediate

YARN
Fingering (#1) weight.

Shown here: Sweet Georgia Cashluxe Fine (70% superwash merino wool, 20% cashmere, 10% nylon; 400 yd [365 m]/ 115 g): English Ivy, 2 hanks.

Brooch or shawl pin, optional.

HOOKS
Size G/6 (4 mm).

Adjust hook size if necessary to obtain gauge.

NOTIONS
Yarn needle.

FINISHED DIMENSIONS
Approx. 51"× 6½" (132 × 16.5 cm).

GAUGE
26 sts = 4" (10 cm), 7 rows = 3" (7.5 cm) in Celtic Weave stitch.

SPECIAL STITCHES
Celtic Weave, Ribbing Using Front Post and Back Post

SCARF

Ch 31.

Row 1: Dc in 3rd ch from hook and in each ch across, turn. (30 sts)

Row 2: Ch 2 (counts as first st here and throughout), [sk next 2 sts, fptr in next 2 sts, working in front of last 2 sts, fptr in 2 skipped sts] across, dc in turning ch, turn.

Row 3: Ch 2, sk first st, bptr in next 2 sts, [sk next 2 sts, bptr in next 2 sts, working behind last 2 sts (will cross on RS), bptr in 2 skipped sts] across to last 2 sts, bptr in last 2 sts, dc in turning ch, turn.

Rows 4–119: Repeat Rows 2 and 3. (At the end of Row 120, scarf should measure approx. 52" [132 cm].)

Row 120: With RS facing and working through both loops of both sides, slip st in each st across ends. Do not fasten off.

RIBBING TRIM

Rnd 1: With RS facing, ch 2, work 2 dc in each row end around, join with slip st in first dc, do not turn. (240 dc, not including turning ch)

Rnds 2–4: Ch 2, [fpdc in next 2 sts, bpdc in next 2 sts] around, join with slip st in first dc, do not turn. Fasten off at the end of Rnd 4.

Join with a slip st to other side of scarf at seam. Repeat Rnds 1–4.

FINISHING

Weave in loose ends.

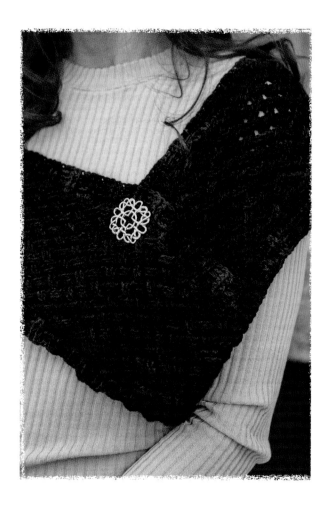

STITCH KEY

⬭	chain (ch)
⊤	double crochet (dc)
	front post treble crochet (fptr)
	back post treble crochet (bptr)

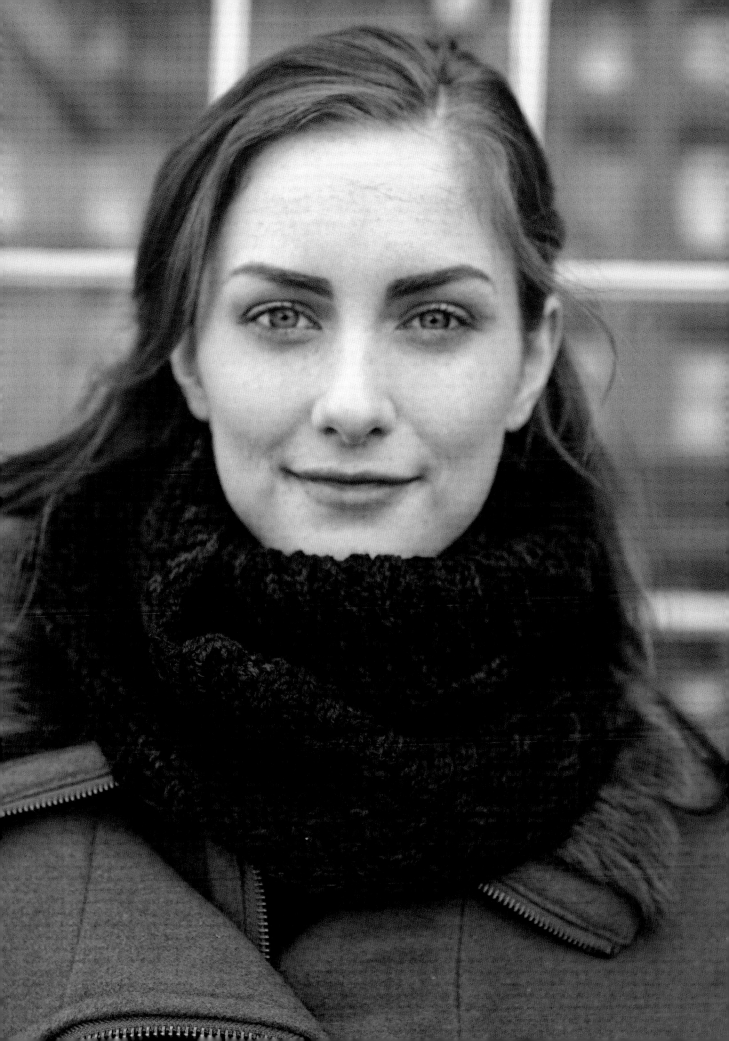

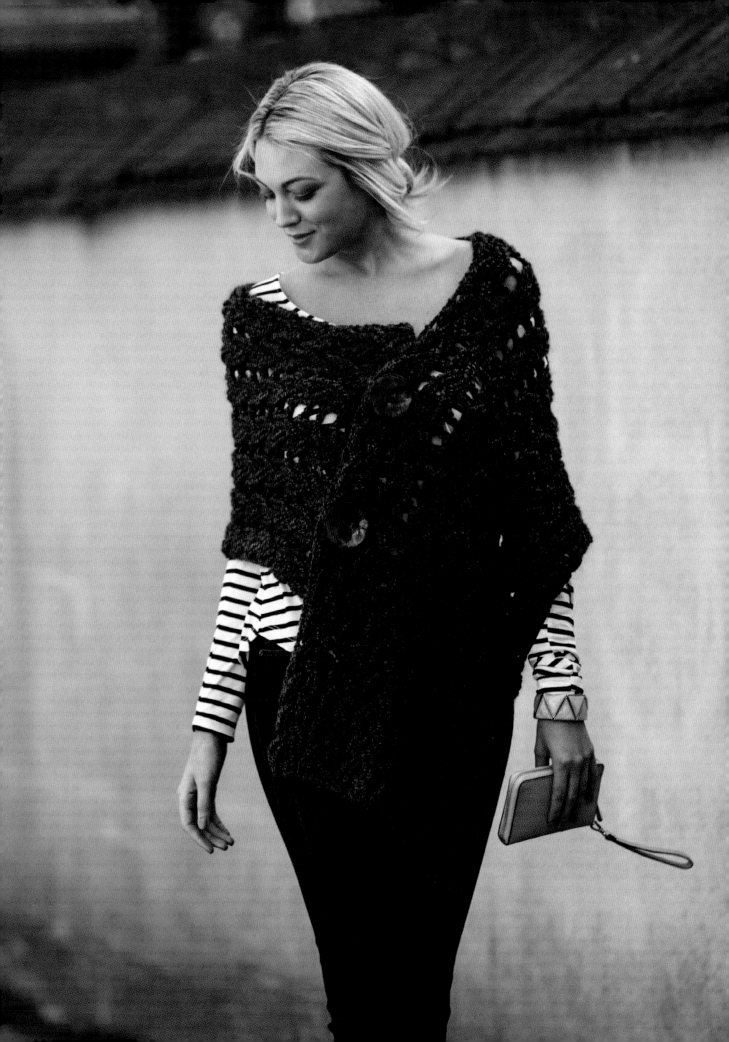

PURPLE PLAITED PONCHO WRAP

This is such a fun and versatile design, and it's very easy to crochet!
If you are a confident beginner, don't be afraid to grab your crochet hook
and dig into this one. The braided cable fabric creates many large holes that
perfectly suit the large decorative buttons and allow you many creative options.
Need a poncho? No problem! A wrap? Or how about a chunky scarf?
You are only limited by your imagination when it comes to
wearing this poncho/wrap/scarf/whatever!

SKILL LEVEL
Confident Beginner

YARN
Bulky (#5) weight.

Shown here: Lion Brand Homespun (98%
acrylic, 2% polyester; 185 yd [169 m]/170 g):
#790-386 Grape, 5 skeins.

HOOKS
Size M/13 (9 mm).

Adjust hook size if necessary to obtain gauge.

NOTIONS
2 decorative buttons, approx. 2½" (6.5 cm).

Yarn needle.

FINISHED DIMENSIONS
Approx. 52" × 17" (132 × 43 cm).

GAUGE
12 sts (or 2 braids) and 6 rows = 5" (12.5 cm)
in Braided Cable pattern stitch.

SPECIAL STITCHES
Braided Cable

PATTERN NOTES
Turning chain does not count as a stitch.

WRAP

Ch 46.

Row 1: Dc in 4th chain from hook and in each ch across. (43 dc)

Row 2: (RS) Ch 3, sk first 3 sts, fptr in next 2 sts, working in front of stitches just made, fptr in 2nd and 3rd sts skipped, fptr in next 2 sts, [sk 2 sts, fptr in next 2 sts, working in front of stitches just made, fptr in 2 skipped sts, fptr in next 2 sts] across row. Dc in turning ch loop (working through complete chain, not just one strand of chain). (42 fptr)

Row 3: Ch 3, sk first 3 sts, bptr in next 2 sts, working behind sts just made (will be crossed on RS), bptr in 2nd and 3rd sts skipped, bptr in next 2 sts, [sk 2 sts, bptr in next 2 sts, working behind sts just made, bptr in 2 skipped sts, bptr in next 2 sts] across row, dc in turning ch loop.

Rows 4–62: Repeat Rows 2 and 3 until piece measures approx. 51" (129.5 cm), ending with a Row 2.

Row 63: Ch 2, bpdc in each st across. Fasten off. Attach large buttons using matching yarn (per photo).

FINISHING

Weave in loose ends.

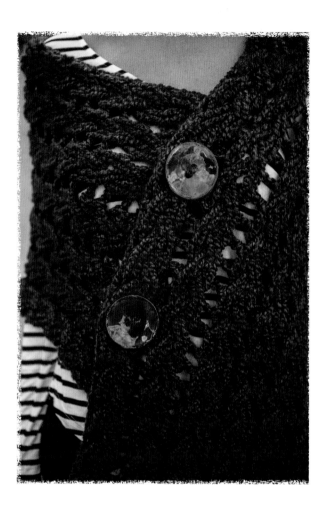

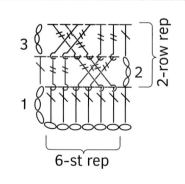

STITCH KEY

⬯ chain (ch)	back post treble crochet (bptr)
double crochet (dc)	
front post treble crochet (fptr)	

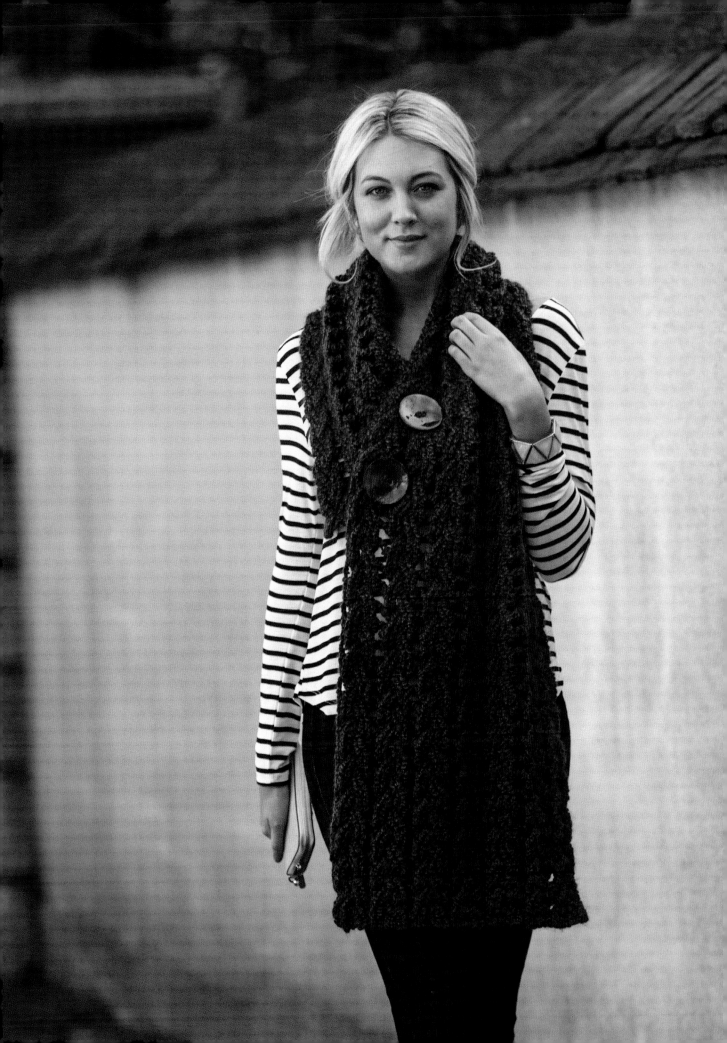

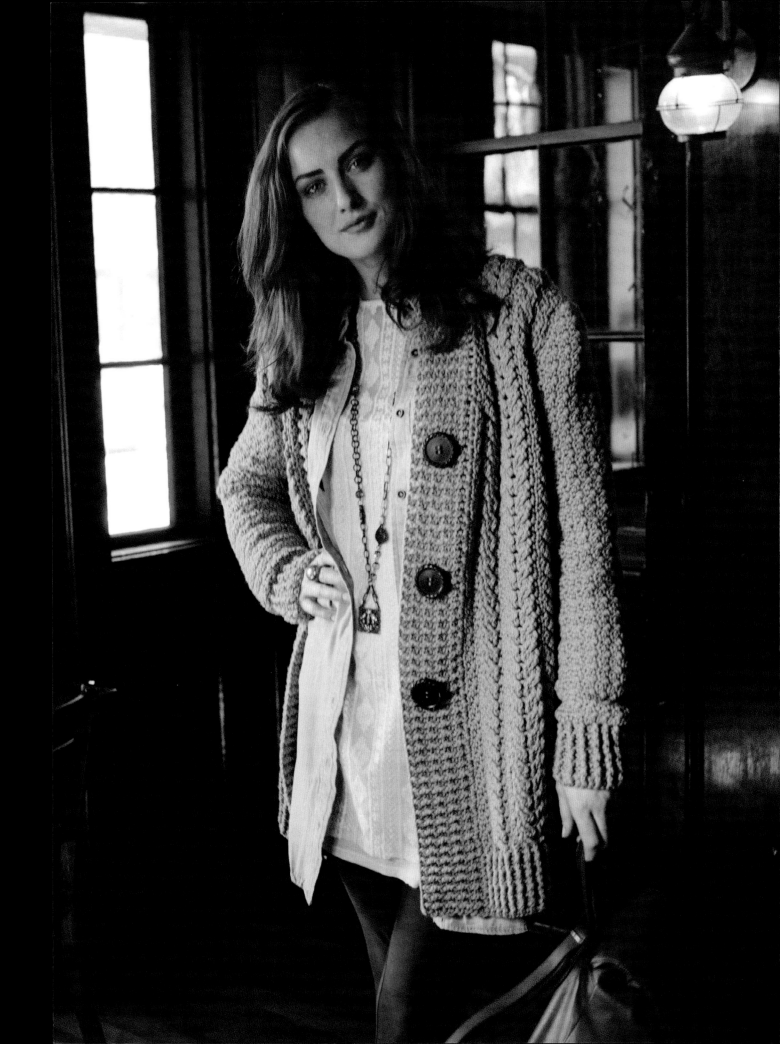

ORLAITH ROBE SWEATER

The Orlaith (Irish for golden princess) Robe Sweater is my go-to sweater on cold Maryland mornings. The length will flatter most figures as well as provide the warmth you need to keep all of you comfortable!

SKILL LEVEL

Confident Beginner to Intermediate

YARN

Worsted (#4) weight.

Shown here: Cascade 220 Superwash Aran (100% superwash merino wool; 150 yd [137.5 m]/ 100 g): #873 Extra Creme Cafe, 14 [15, 16, 16, 17, 18, 19] hanks.

HOOKS

Size I/9 (5.5mm).

Adjust hook size if necessary to obtain gauge.

NOTIONS

3 buttons, 2½" (6.5 cm) in diameter.

Yarn needle.

SIZES/FINISHED DIMENSIONS

XS (S, M, L, XL, 2X, 3X). See schematics for specific measurements.

GAUGE

13 sts and 11 rows= 4" (10 cm) in [sc, dc] pattern.

SPECIAL STITCHES

Double Stitch (sc, dc), Four-Stitch Post Cable, Wheat Cable

PATTERN NOTES

Turn at the end of each row.

Please note that the cabling in this sweater is formed using fpdc instead of fptr.

BACK

Note: The Back is worked from bottom to top.

Ch 71 (75, 79, 83, 87, 87, 87).

Row 1: Dc in 3rd ch from hook and in each ch across. (69 [73, 77, 81, 85, 85, 85] sts, not including turning ch)

Row 2: (RS; begin ribbing rows) Ch 2, [fpdc, bpdc] across, hdc in turning ch.

Row 3: Ch 2, [fpdc, bpdc] across, hdc in turning ch.

Rows 4–9: Repeat Row 3.

Row 10: (Begin cabling rows) Starting in next st, [sc, dc] 6 times, ★ 4-St Post Cable [sk 2 sts, fpdc in next 2 sts, working in front of sts just made, fpdc in skipped sts], sc, dc, Wheat Cable [sk 2 sts, fpdc in next 2 sts, working in back of sts just made, fpdc in skipped sts, sk 2 sts, fpdc in next 2 sts working in front of last 2 sts, fpdc in skipped sts], sc, dc, 4-St Post Cable [sk 2 sts, fpdc in next 2 sts, working in front of sts just made, fpdc in skipped sts], ★★ [sc, dc] 2 (4, 6, 8, 10, 10, 10) times; repeat from ★ to ★★ once more, [sc, dc] 6 times, working last dc in turning ch.

Row 11: Ch 1, starting in the first st, [sc, dc] 6 times, ★4 bpdc, sc, dc, 8 bpdc, sc, dc, 4 bpdc, ★★ [sc, dc] 2 (4, 6, 8, 10, 10, 10) times; repeat from ★ to ★★ once more, [sc, dc] 6 times.

Rows 12–56 (58, 60, 60, 62, 62, 62): Repeat Rows 10 and 11 ending with a repeat of Row 10.

Row 57 (59, 61, 61, 63, 63, 63): (Armhole decreases begin) Slip st in first 4 sts, dc2tog in next 2 sts, continue in established pattern to last 6 sts, dc2tog in next 2 sts, turn, leaving remaining sts unworked. (58 [62, 66, 70, 74, 74, 74] sts)

Row 58 (60, 62, 62, 64, 64, 64): Ch 1, dc2tog in first 2 sts, continue in patt to last 2 sts, dc2tog in last 2 sts, turn. (56 [60, 64, 68, 72, 72, 72] sts)

Next 2 rows: Repeat last row. (52 [56, 60, 64, 68, 68, 68] sts)

Next 14 (15, 15, 16, 19, 20, 21) rows: Work in established patt. Fasten off.

RIGHT FRONT PANEL

Ch 37 (39, 41, 43, 45, 45, 45).

Row 1: Dc in 3rd ch from hook and in each ch across, turn. (35 [37, 39, 41, 43, 43, 43] dc, not including turning ch)

Row 2: (RS, begin ribbing rows) Ch 2, [fpdc, bpdc] across, hdc in turning ch, turn.

Row 3: Ch 2, [fpdc, bpdc] across, hdc in turning ch, turn.

Rows 4–9: Repeat Row 3.

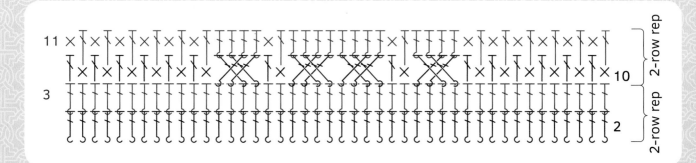

STITCH KEY

✕ single crochet (sc)

⊤ double crochet (dc)

Ŧ front post double crochet (fpdc)

Ŧ back post double crochet (bpdc)

Row 10: Ch 1, (begin cabling rows) starting in next st [sc, dc] 1 (2, 3, 4, 5, 5, 5) time(s), 4-St Post Cable [sk 2 sts, fpdc in next 2 sts, working in front of sts just made, fpdc in skipped sts], sc, dc, Wheat Cable [sk 2 sts, fpdc in next 2 sts, working in back of sts just made, fpdc in skipped sts, sk 2 sts, fpdc in next 2 sts working in front of last 2 sts, fpdc in skipped sts], sc, dc, 4-St Post Cable [sk 2 sts, fpdc in next 2 sts, working in front of sts just made, fpdc in skipped sts], [sc, dc] 6 times , do not work in turning ch, turn.

Row 11: Ch 1, [sc, dc] 6 times, 4 bpdc, sc, dc, 8 bpdc, sc, dc, 4 bpdc, [sc, dc] 1 (2, 3, 4, 5, 5, 5) time(s), turn.

Rows 12–56 (58, 60, 60, 62, 62, 62): Repeat Rows 10 and 11 across, ending with a repeat of Row 10.

Row 57 (59, 61, 61, 63, 63, 63): Ch 1, slip st in first 4 sts, dc2tog in next 2 sts, continue in pattern st across to last 2 sts, dc2tog in last 2 sts (at neck edge), turn. (29 [31, 33, 35, 37, 37, 37] sts)

Row 58 (60, 62, 62, 64, 64, 64): Work in established patt to last 2 sts, dc2tog in last 2 sts, turn. (28 [30, 32, 34, 36, 36, 36] sts)

Row 59 (61, 63, 63, 65, 65, 65): Ch 1, dc2tog in first 2 sts, work in established patt to last 2 sts (at neck edge), dc2tog in last 2 sts, turn. (27 [29, 31, 33, 35, 35, 35] sts)

Row 60 (62, 64, 64, 66, 66, 66): Repeat Row 58 (60, 62, 62, 64, 64, 64). (26 [28, 30, 32, 34, 34, 34] sts)

Row 61 (63, 65, 65, 67, 67, 67): Work in established patt to last 2 sts, dc2tog in last 2 sts (at neck edge), turn. (25 [27, 29, 31, 33, 33, 33] sts)

Row 62 (64, 66, 66, 68, 68, 68): Work in established patt.

Next 4 rows: Repeat last 2 rows twice. (23 [25, 27, 29, 31, 31, 31] sts)

Row 67 (69, 71, 71, 73, 73, 73): Repeat Row 61 (63, 65, 65, 67, 67, 67). (22 [22, 26, 28, 30, 30, 30] sts)

Next 7 (8, 8, 9, 12, 13, 14) rows: Work in established pattern across 22 (24, 26, 28, 30, 30, 30) sts. Fasten off. Length of this piece should be same as Back piece.

LEFT FRONT PANEL

Ch 37 (39, 41, 43, 45, 45, 45).

Row 1: Dc in 3rd ch from hook and in each ch across [35 (37, 39, 41, 43, 43, 43) dc, not including turning ch], turn.

Row 2: (Begin ribbing rows) Ch 2, [fpdc, bpdc] across, hdc in turning ch, turn.

Row 3: Ch 2, [fpdc, bpdc] across, hdc in turning ch, turn.

Rows 4–9: Repeat Row 3.

Row 10: Ch 1, (begin cabling rows) sk first st, starting in next st [sc, dc] 6 times, 4-St Post Cable [sk 2 sts, fpdc in next 2 sts, working in front of sts just made, fpdc in skipped sts], sc, dc, Wheat Cable [sk 2 sts, fpdc in next 2 sts, working in back of sts just made, fpdc in skipped sts, sk 2 sts, fpdc in next 2 sts working in front of last 2 sts, fpdc in skipped sts], sc, dc, 4-St Post Cable [sk 2 sts, fpdc in next 2 sts, working in front of sts just made, fpdc in skipped sts], [sc, dc] 1 (2, 3, 4, 5, 5, 5) time(s), do not work in turning ch, turn.

Row 11: Ch 1, [sc, dc] 1 (2, 3, 4, 5, 5, 5) time(s), 4 bpdc, sc, dc, 8 bpdc, sc, dc, 4 bpdc, [sc, dc] 6 times, turn.

Rows 12–56 (58, 60, 60, 62, 62, 62): Repeat Rows 10 and 11 across, ending with a repeat of Row 10.

Row 57 (59, 61, 61, 63, 63, 63): Ch 1, dc2tog in last 2 sts (at neck edge), continue in established patt across to last 6 sts, dc2tog in next 2 sts, leaving rem 4 sts unworked, turn. (29 [31, 33, 35, 37, 37, 37] sts)

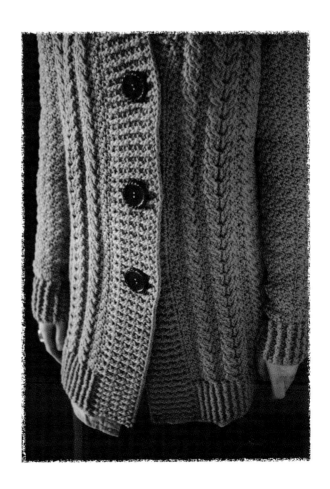

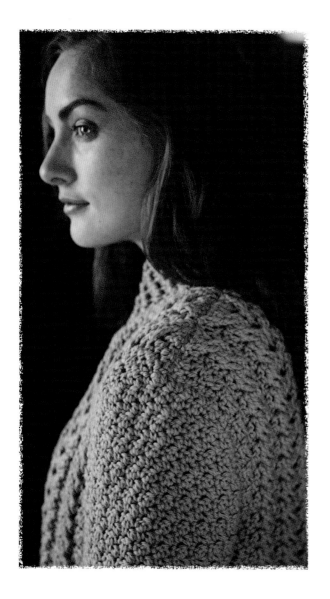

Next 4 rows: Repeat last 2 rows twice. (23 [25, 27, 29, 31, 31, 31] sts)

Row 67 (69, 71, 71, 73, 73, 73): Repeat Row 61 (63, 65, 65, 67, 67, 67). (22 [22, 26, 28, 30, 30, 30] sts)

Next 8 (9, 9, 10, 13, 14, 15) rows: Work in established patt across 22 (24, 26, 28, 30, 30, 30) sts. Fasten off. Length of this piece should be same as Back piece.

SLEEVES (Make 2)

Ch 31 (33, 35, 39, 41, 45, 49).

Row 1: Dc in 3rd ch from hook and in each ch across, turn. (29 [31, 33, 37, 39, 43, 47] sts, not counting turning ch)

Row 2: Ch 2, [fpdc, bpdc] across, hdc in turning ch.

Rows 3–9: Repeat Row 2.

Row 10: Ch 1, starting in first st, [sc, dc] across, do not work in turning ch, turn. (28 [30, 32, 36, 38, 42, 46] sts)

Sizes L, XL, 2X, and 3X only

Rows 11–13: Repeat Row 10.

All sizes

Row 11 (11, 11, 14, 14, 14, 14): (Increase row) Ch 1, (dc, sc) in the first sc (inc made), [dc, sc] across to last st, (dc, sc) in the last st (inc made), turn. (30 [32, 34, 38, 40, 44, 48] sts)

Rows 18–22 (18–22, 18–22, 21–25, 21–25, 21–25, 21–25): Ch 1, [dc, sc] across, turn.

Row 17 (17, 17, 20, 20, 20, 20): (Increase row) Ch 1, (sc, dc) in first st, [sc, dc] across to last st, (sc, dc) in last st, turn. (32 [34, 36, 40, 42, 46, 50] sts)

Next 5 rows: [Sc, dc] across, turn.

Rows 23–34 (23–34, 23–34, 26–37, 26–37, 26–37, 26–37): Repeat Rows 11–22 (11–22, 11–22, 14–25, 14–25, 14–25, 14–25). (36 [38, 40, 44, 46, 50, 54] sts)

Next 10 rows: Repeat Rows 11–20 (11–20, 11–20, 14–23, 14–23, 14–23, 14–23). (40 [42, 44, 48, 50, 54, 58] sts)

Next row: Repeat Row 17(17, 17, 20, 20, 20, 20). (42 [44, 46, 50, 52, 56, 60] sts)

Next 2 rows: [Sc, dc] across.

Row 58 (60, 62, 62, 64, 64, 64): Ch 1, dc2tog in first 2 sts, work in established patt across, turn. (28 [30, 32, 34, 36, 36, 36] sts)

Row 59 (61, 63, 63, 65, 65, 65): Ch 1, dc2tog in first 2 sts (at neck edge), work in established patt to last 2 st, dc2tog in last 2 sts, turn. (27 [29, 31, 33, 35, 35, 35] sts)

Row 60 (62, 64, 64, 66, 66, 66): Repeat Row 58 (60, 62, 62, 64, 64, 64). (26 [28, 30, 32, 34, 34, 34] sts)

Row 61 (63, 65, 65, 67, 67, 67): Ch 1, dc2tog in first 2 sts (at neck edge), work in established patt across, turn. (25 [27, 29, 31, 33, 33, 33] sts)

Row 62 (64, 66, 66, 68, 68, 68): Work in established patt.

SLEEVE CAP

(Continuing from Sleeve instructions above)

Row 1: Slip st in first 4 sts, dc2tog in next 2 sts, work in established patt to last 6 sts, dc2tog in next 2 sts, turn, leaving remaining 4 sts unworked. (32 [34, 36, 40, 42, 46, 50] sts)

Row 2: Work in established patt across.

Row 3: Ch 1, dc2tog in first 2 sts, work in established patt to last 2 sts, dc2tog in last 2 sts, turn. (30 [32, 34, 38, 40, 44, 48] sts)

Rows 4–19 (21, 21, 23, 25, 27, 29): Repeat Rows 2 and 3 a total of 8 (8, 8, 9, 10, 11, 12) times. (14 [14, 16, 18, 18, 20, 22] sts)

FINISHING

Sew shoulder seams. Sew arms in place and then sew arm and side seams.

NECK BAND RIBBING

Row 1: With RS facing, join with a slip st to bottom right of sweater on Right Front Panel, ch 2, dc evenly (approx. 3 dc for every 2 row ends) along the row ends up the Right Front Panel, around neck edge, and down the Left Front Panel of sweater, turn.

Rows 2–4: Ch 2, [fpdc, bpdc] across, hdc in turning ch, turn. At the end of Row 4, mark the desired location for 3 large buttonholes on Left Front Panel.

Row 5: Ch 2, [fpdc, bpdc] to location of buttonhole, *ch 4, sk four sts, [fpdc, bpdc] to next buttonhole; repeat from * twice more, [fpdc, bpdc] to end of row, hdc in turning ch, turn.

Row 6: Ch 2, [fpdc, bpdc] to location of buttonhole sp, *4 dc in ch-4 sp, [fpdc, bpdc] to next buttonhole sp; repeat from * twice more, [fpdc, bpdc] to end of row, hdc in turning ch, turn.

Rows 7–9: Ch 2, [fpdc, bpdc] across, hdc in turning ch, turn. Fasten off at the end of Row 9.

Sew buttons in place. Weave in loose ends.

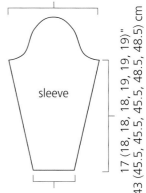

13 (13½, 14, 15½, 16, 17, 18½)"
33 (34.5, 35.5, 39.5, 40.5, 43, 47) cm

17 (18, 18, 18, 19, 19, 19)"
43 (45.5, 45.5, 45.5, 48.5, 48.5, 48.5) cm

sleeve

7½ (8, 8, 8½, 9, 9½, 9½)"
19 (20.5, 20.5, 21.5, 23, 24, 24) cm

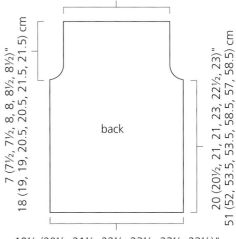

16 (17, 18½, 19½, 21, 21, 21)"
40.5 (43, 47, 49.5, 53.5, 53.5, 53.5) cm

7 (7½, 7½, 8, 8, 8½, 8½)"
18 (19, 19, 20.5, 20.5, 21.5, 21.5) cm

back

20 (20½, 21, 21, 23, 22½, 23)"
51 (52, 53.5, 53.5, 58.5, 57, 58.5) cm

19½ (20½, 21½, 22½, 23½, 23½, 23½)"
49.5 (52, 54.5, 57, 59.5, 59.5, 59.5) cm

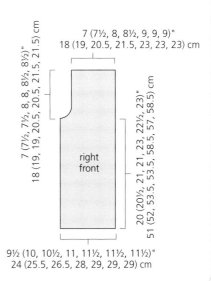

7 (7½, 8, 8½, 9, 9, 9)"
18 (19, 20.5, 21.5, 23, 23, 23) cm

7 (7½, 7½, 8, 8, 8½, 8½)"
18 (19, 19, 20.5, 20.5, 21.5, 21.5) cm

right front

20 (20½, 21, 21, 23, 22½, 23)"
51 (52, 53.5, 53.5, 58.5, 57, 58.5) cm

9½ (10, 10½, 11, 11½, 11½, 11½)"
24 (25.5, 26.5, 28, 29, 29, 29) cm

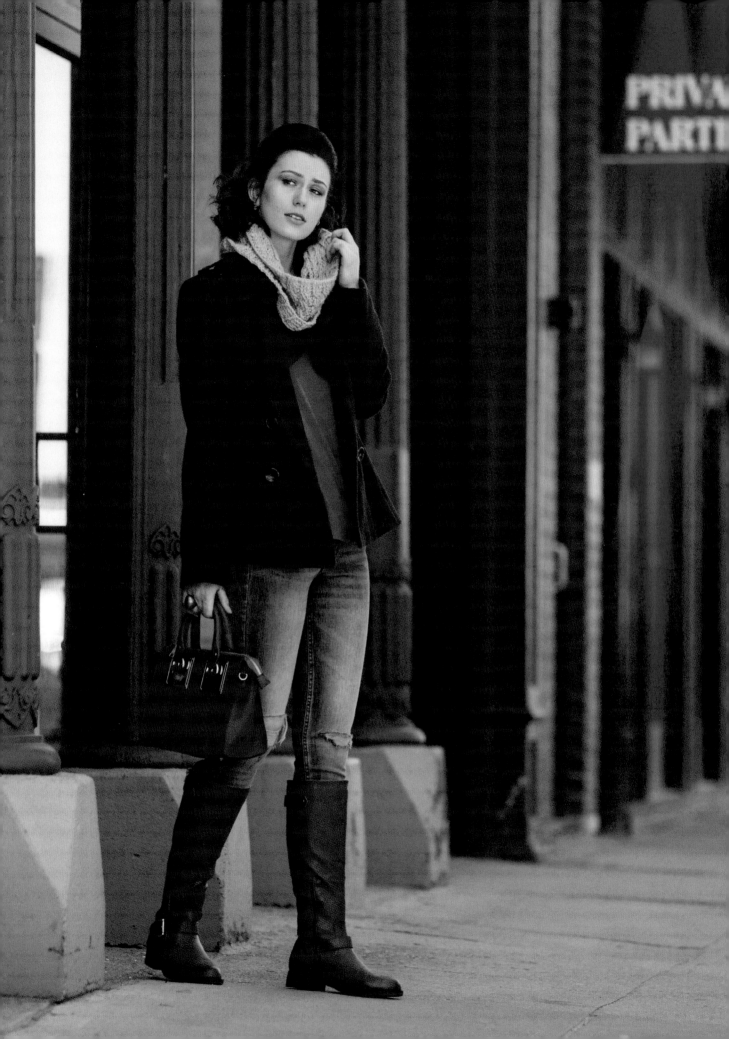

CELTIC CABLED COWL

Here is a classic way to stay warm and cozy without having to worry about fumbling with a longer scarf. I love the way cowls like this—made of all natural fibers—keep you warm and stylish without a lot of fuss! This design combines two different cables that work up quickly and with a minimal amount of fiber.

SKILL LEVEL

Intermediate

YARN

DK (#3) weight.

Shown here: Juniper Moon Farm Herriot (100% alpaca; 218 yd [200 m]/100 g): #05 Ghost Fern, 2 hanks.

HOOKS

Size I/9 (5.5 mm).

Adjust hook size if necessary to obtain gauge.

NOTIONS

Yarn needle.

FINISHED DIMENSIONS

30" × 6½" (76 × 16.5 cm).

GAUGE

15 sts = 4" (10 cm), 3 rows = 1" (2.5 cm) in ribbing pattern (3 fpdc, 1 bpdc).

SPECIAL STITCHES

Celtic Weave, Four-Stitch Post Cable, Ribbing Using Front Post and Back Post

PATTERN NOTES

This Celtic Cabled Cowl is worked in the round. If using the online instructional videos, please be sure to view "Celtic Weave in the Round."

The even-numbered rounds will have the front side facing.

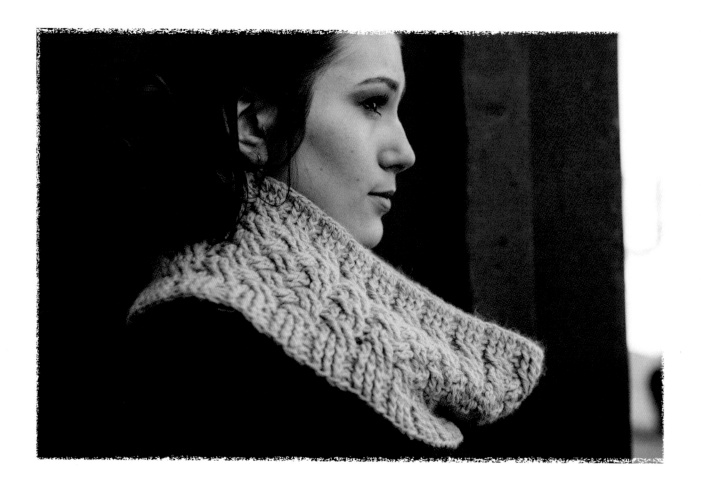

COWL

Ch 112, join with a slip st to the first ch, being careful not to twist.

Rnd 1: (RS) Ch 2, dc in same ch as joining and in each ch around. Join with a slip st to first st of rnd. (112 sts, not including turning ch) Do not turn.

Rnd 2: (RS) Ch 2, [fpdc in 3 sts, bpdc in 1 st] around. Join with a slip st to first st of rnd. Do not turn.

Rnd 3: Repeat Rnd 2.

Rnd 4: (RS) Ch 2, [sk first 2 sts, fptr in next 2 sts, working in front of sts just worked, fptr in 2 skipped sts] around. Join with a slip st to first st of rnd. Turn.

Note: This rnd will help to establish the pattern that distinguishes the Celtic Weave stitch from the Four-Stitch Post Cable.

Rnd 5: (WS) Ch 2, ★bptr in 2 sts, [sk 2 sts, bptr in next 2 sts, working behind sts just worked (on RS they will cross in front), bptr in 2 skipped sts] twice, bptr in next 2 sts, bpdc in next 4 sts (for 4-St Post Cable); rep from ★ around. Join with a slip st to first st of rnd. Turn.

Rnds 6–11: Repeat Rnds 4 and 5 three more times.

Rnd 12: Repeat Rnd 4.

Rnd 13: (WS) Bpdc in each st around. Join with a slip st to first st of rnd. Turn.

Rnds 14–16: (RS) Repeat Rnd 2. Finish off at the end of Rnd 16.

FINISHING

Weave in loose ends.

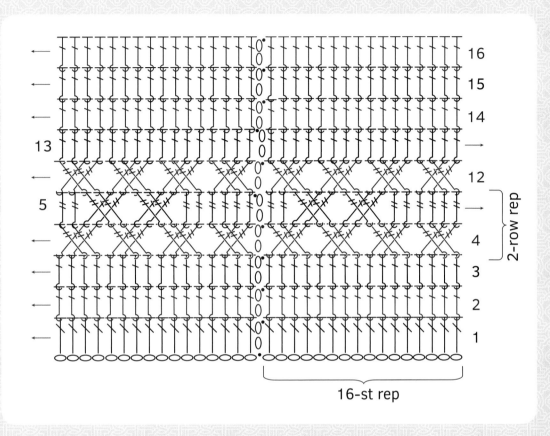

16

15

14

13

12

5

2-row rep

4

3

2

1

16-st rep

STITCH KEY

- slip st

 chain (ch)

double crochet (dc)

front post double crochet (fpdc)

back post double crochet (bpdc)

front post treble crochet (fptr)

back post treble crochet (bptr)

→ indicates direction of rows or rounds

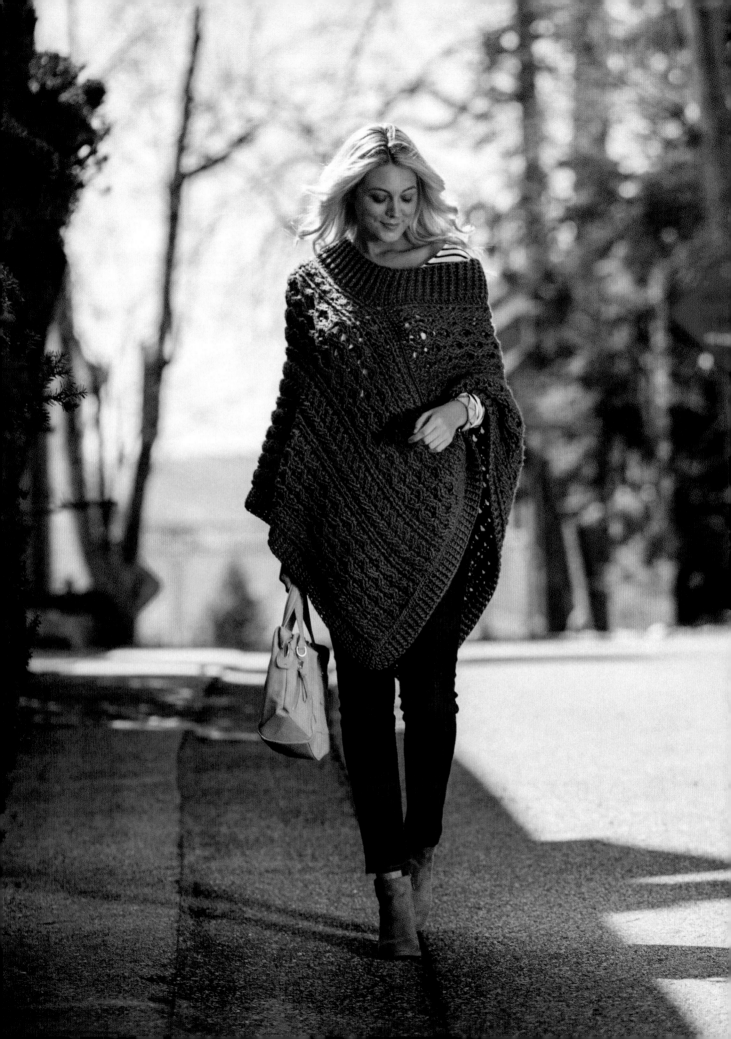

LAVENA PONCHO

In case you haven't noticed, I'm a child of the 1960s and still find myself hopelessly in love with ponchos! This poncho is like wearing a warm and cozy blanket. The Irish name Lavena means joy, and it is my hope that crocheting and wearing this design will bring you just that! All the cables are very similar to stitch yet produce very different effects that I think you will enjoy.

SKILL LEVEL

Intermediate

YARN

Worsted (#4) weight.

Shown here: Lion Brand Heartland (100% acrylic; 251 yd [230 m]/142 g): #136-125 Mammoth Cave, 8 skeins.

HOOKS

Size K/10.5 (6.5 mm).

Adjust hook size if necessary to obtain gauge.

NOTIONS

Yarn needle.

FINISHED DIMENSIONS

Approx. 31" (79 cm) from top of collar to bottom of poncho; 40" (101.5 cm) side to side at widest point.

GAUGE

7 sts and 4 rows = 2" (5 cm) in pattern stitch across bottom.

SPECIAL STITCHES

Four-Stitch Post Cable, Honeycomb Cable, Ribbing Using Front Post and Back Post, Wheat Cable

PATTERN NOTES

This design consists of 2 rectangular panels that are crocheted together to form the poncho.

At the end of each row, turn.

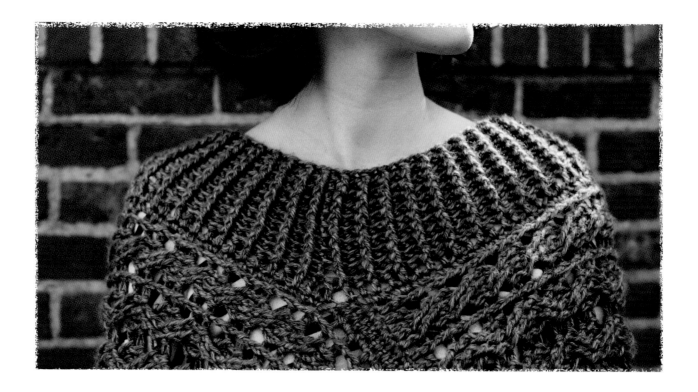

PANELS (Make 2)

Ch 64.

Row 1: Dc in 4th ch from hook and in each ch across, turn. (62 sts)

Row 2: (RS) Fpdc, sk next 2 sts, fptr in next 2 sts, working in front of last 2 sts, fptr in 2 skipped sts, fpdc in next st, ★ (Honeycomb Cables) [sk 2 sts, fptr in next 2 sts, working behind last 2 sts, fptr in skipped sts, sk 2 sts, fptr in next 2 sts, working in front of last 2 sts, fptr in 2 skipped sts] twice★★, bpdc in next st, fpdc in next 2 sts, bpdc in next st, (Wheat Cable) [sk 2 sts, fptr in next 2 sts, working behind last 2 sts, fptr in skipped sts, sk 2 sts, fptr in next 2 sts, working in front of last 2 sts, fptr in 2 skipped sts], bpdc in next st, fpdc in next 2 sts, bpdc in next st, rep between ★ and ★★, fpdc, sk next 2 sts, fptr in next 2 sts, working in front of last 2 sts, fptr in 2 skipped sts, fpdc in next st, hdc in turning ch, turn.

Row 3: Ch 2, bpdc over 22 sts, fpdc, 2 bpdc, fpdc, 8 bpdc, fpdc, 2 bpdc, fpdc, bpdc over last 22 sts, hdc in turning ch, turn.

Row 4: Ch 2, fpdc, sk next 2 sts, fptr in next 2 sts, working in front of last 2 sts, fptr in 2 skipped sts, fpdc in next st, ★ (Honeycomb Cable) [sk 2 sts, fptr in next 2 sts, working in front of last 2 sts, fptr in skipped sts, sk 2 sts, fptr in next 2 sts, working behind last 2 sts, fptr in 2 skipped sts] twice★★, bpdc in next st, fpdc in next 2 sts, bpdc in next st, (Wheat Cable) [sk 2 sts, fptr in next 2 sts, working behind last 2 sts, fptr in skipped sts, sk 2 sts, fptr in next 2 sts, working in front of last 2 sts, fptr in 2 skipped sts], bpdc in next st, fpdc in next 2 sts, bpdc in next st, rep between ★ and ★★ once, fpdc, sk next 2 sts, fptr in next 2 sts, working in front of last 2 sts, fptr in 2 skipped sts, fpdc in next st, hdc in turning ch, turn.

Row 5: Repeat Row 3.

Rows 6–69: Repeat Rows 2–5 sixteen more times, do not fasten off.

PERIMETER

Rnd 1: With RS facing, ch 1, ★work 61 sc across, ch 2, rotate work 90 degrees, work 112 sc evenly across long edge of panel, ch 2, rotate work 90 degrees, rep from ★ once, slip st in first sc to join. Fasten off. (346 sc, 4 ch-2 corners)

JOINING PANELS

Note: See diagram below.

Seam according to the diagram, joining side B to section A of the other rectangle, aligning the corners with matching symbols. With RS together, working through both layers, join with a slip st in the ch-2 corners of each piece, continuing through both layers, slip st next 61 sts and ch-2 corner. Finish off.

Join other seam in the same manner.

RIBBING TRIM AROUND NECK SECTION

Rnd 1: With RS facing, join with a slip st to inside neck corner. Ch 3 (counts as first dc), work 101 dc evenly around. (102 dc)

Rnd 2: Ch 2, [fpdc, bpdc] around to last st, fpdc, join to first st of rnd.

Rnds 3–10: Repeat Rnd 2. Finish off.

RIBBING TRIM AROUND BOTTOM

Rnd 1: Join with a slip st anywhere along side of poncho except the corner area. Ch 2, dc in each st around, working 6 dc into both corner points of poncho, join in first dc of rnd. (360 sts)

Rnd 2: Ch 2 (counts as first st), [fpdc, bpdc] around to last st, fpdc, join to first st of rnd.

Rnds 3–5: Repeat Rnd 2. Finish off.

FINISHING

Weave in loose ends.

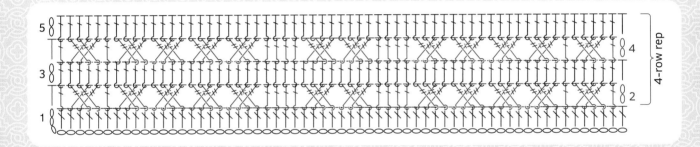

LAVENA PONCHO ASSEMBLY DIAGRAM

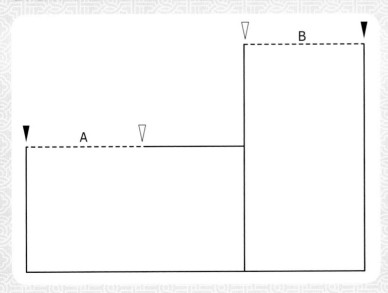

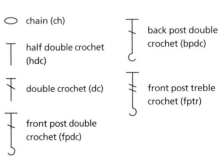

STITCH KEY

chain (ch)

half double crochet (hdc)

double crochet (dc)

front post double crochet (fpdc)

back post double crochet (bpdc)

front post treble crochet (fptr)

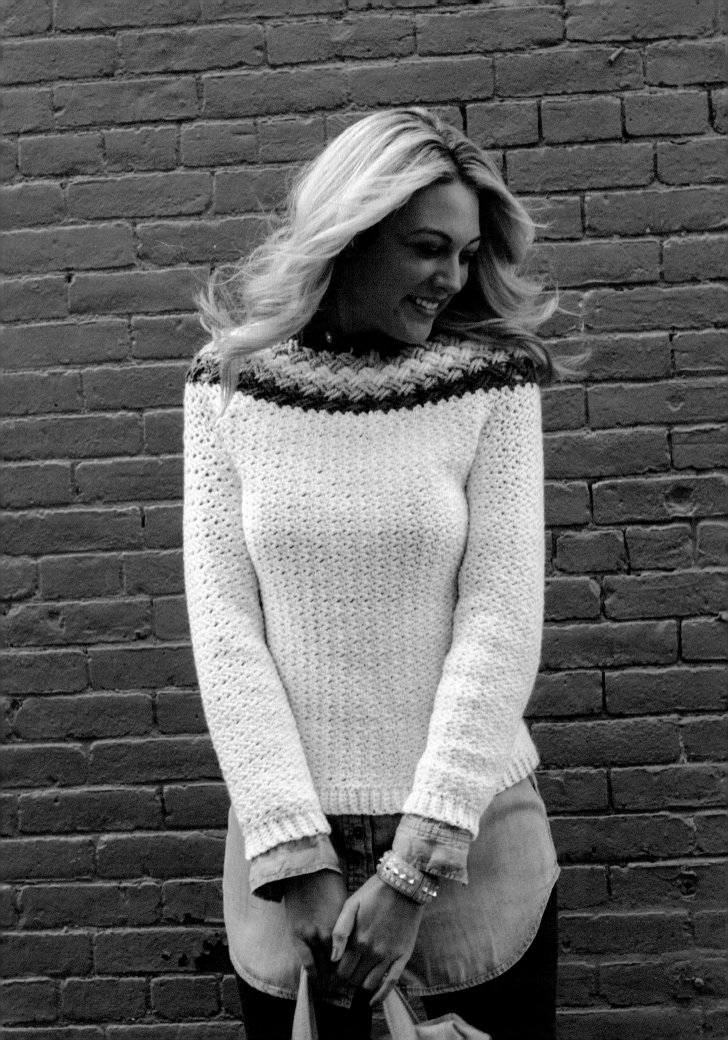

VICKI'S SWEATER

This special no-sew pullover sweater is named in honor of one of my very special friends who has been a great inspiration to me in many ways, not the least of which is in her use of color in her beautiful crocheted creations. I hope you enjoy not having to sew this one together as much as I do! These stitches embody a lot of elasticity to fit most figures beautifully.

SKILL LEVEL

Intermediate

YARN

DK (#3) weight yarn.

Shown here: Berroco Vintage DK (52% acrylic, 40% wool, 8% nylon; 288 yds [263 m]/100 g): MC #2101 Mochi, 4 [5, 6, 7, 7, 8, 8] hanks; CC1 #2155 Delphinium, 1 hank; CC2 #2114 Aster, 1 hank.

HOOKS

Size H/8 (5 mm).

Adjust hook size if necessary to obtain gauge.

NOTIONS

Locking stitch markers.

2 buttons, ½" (1.3 cm) in diameter, sizes XS and S only.

Yarn needle.

SIZES/FINISHED DIMENSIONS

XS (S, M, L, XL, 2X, 3X). See schematics for measurements.

GAUGE

7 clusters and 14 cluster rows = 4" (10 cm).

SPECIAL STITCHES

Celtic Weave

Cluster

Working over a sample of 20 sc:

Row 1: Ch 1, *(sc, ch 1, dc) in next st (one cluster made), sk next st; repeat from * across, turn.

Row 2: Ch 1, *(sc, ch 1, sc) in next ch-1 sp; rep from * across, turn.

PATTERN NOTES

Unless otherwise stated, join with a slip st to first st of row (not the turning chain).

The even rows have the RS facing; the odd-numbered rows have the WS facing.

The XS and S sizes will have a button closure at the collar; the other sizes will not.

COLLAR

Sizes XS and S only

Using CC1, ch 59 (67).

Row 1: Dc in 3rd ch from hook (skipped chs do not count as dc) and in each ch across, turn. (57 [65] sts)

Row 2: Ch 3, sk first st, [sk next 2 sts, fptr in next 2 sts, working in front of last 2 sts, fptr in 2 skipped sts, 2 dc between last dc worked and next dc] across, dc in turning ch, turn. (85 [97] sts)

Row 3: Ch 2, [2 dc in each of next 2 dc, bpdc in next 4 tr (cable from previous row)] across, join with slip st in first dc of row to continue working in the rnd, turn. (112 [128] sts)

Directions for Rnd 4 are listed below under "All sizes."

Sizes M, L, XL, 2X, and 3X only

Using CC1, ch 72 (80, 88, 96, 104) and join to first ch to form ring.

Rnd 1: Ch 2, dc in same space as joining and in each ch around, turn. (72 [80, 88, 96, 104] sts)

Rnd 2: Ch 3, [sk first two sts, fptr in next 2 sts, working in front of last 2 sts, fptr in 2 skipped sts, 2 dc between last dc and next dc] around, turn. (108 [120, 132, 144 156] sts)

Rnd 3: Ch 2, [2 dc in each of next 2 dc, bpdc in next 4 tr (cable from previous row)] around, join with slip st to first st of rnd, turn. (144 [160, 176, 192, 208] sts)

All sizes

The following row begins the Celtic Weave stitch. Change to CC2.

Rnd 4: (RS) Ch 3, place marker in turning ch, sk first 4 sts, fptr in next 2 sts, working in front of last 2 sts, fptr in last 2 skipped sts, [sk next 2 sts, fptr in next 2 sts, working in front of last 2 sts, fptr in last 2 skipped sts] around, join with a slip st in top of first st of rnd, turn.

Rnd 5: Ch 3, (move marker to top of turning ch this rnd and each rnd of yoke), sk first 4 sts, bptr in next 2 sts, working behind 2 sts just worked, bptr in 3rd and 4th skipped sts (the first 2 sts of the 4 sts skipped will be the last 2 sts worked on this row). [Sk next two sts, bptr in next 2 sts, bptr in 2 skipped sts] around, sk last 2 sts of rnd, bptr in skipped sts at beg of rnd, working behind 2 sts just worked, bptr in 2 last skipped sts, join with slip st in turning ch, turn.

Change to MC.

Rnds 6 and 7: Repeat Rnds 4 and 5.
Change to CC2.

Rnds 8 and 9: Repeat Rnds 4 and 5.
Change to CC1.

Rnds 10 and 11: Repeat Rnds 4 and 5.
Change to MC.

Rnd 12: Ch 1, move marker to this ch, ★(sc, ch 1, dc) in first st (one cluster made), sk next st; repeat from ★ around, join with slip st in first st of rnd, turn. (56 [64, 72, 80, 88, 96, 104] clusters)

Rnd 13: Ch 1, move marker to this ch, (sc, ch 1, dc) in next ch-1 sp (of cluster) and in each ch-1 sp around, join with slip st in first sc of rnd, turn.

Rnds 14 and 15: Repeat Rnd 13. Fasten off.

FRONT OF YOKE

With RS facing, from marked st at center of Back, working clockwise around Yoke, count 16 (19, 21, 24, 27, 30, 34) ch-sps and mark next ch-sp, labeling it marker A. From center marker, working counterclockwise around Yoke, count 11 (13, 14, 16, 16, 17, 17) sts and mark next st, labeling it marker B.

Row 1: With RS facing, join yarn with slip st in ch-sp marked A, ch 1, (sc, ch 1, dc) in same st, (sc, ch 1, dc) in next (23 [26, 29, 32, 33, 34, 35] ch-1 spaces, sc in next sc, leaving remaining sts unworked, turn. (24 [27, 30, 33, 34, 35, 36] total clusters plus one sc)

Rows 2–9 (11, 11, 13, 15, 17, 19): Ch 1, (sc, ch 1, dc) in next 24 [27, 30, 33, 34, 35, 36] ch-1 spaces, sc in top of first sc of last row, turn. Fasten off at end of Row 9 (11, 11, 13, 15, 17, 19).

BACK OF YOKE

Row 1: With RS facing, join yarn with slip st in ch-sp marked B, ch 1, (sc, ch 1, dc) in same st, (sc, ch 1, dc) in next (23 [26, 29, 32, 33, 34, 35] ch-1 spaces, sc in next sc, leaving remaining sts unworked, turn. (24 [27, 30, 33, 34, 35, 36] total clusters plus one sc)

Rows 2–9 (11, 11, 13, 15, 17, 19): Ch 1, (sc, ch 1, dc) in next 24 [27, 30, 33, 34, 35, 36] ch-1 spaces, sc in top of first sc of last row, turn.

DO NOT FASTEN OFF at end of Row 9 (11, 11, 13, 15, 17, 19). Continue to next rnd to connect front and back.

CONNECTING FRONT AND BACK

Sizes XS, S, M, L, and XL only

Next rnd: (WS) Ch 1, (sc, ch 1, dc) in each ch-sp across back Yoke and then in each ch-sp across front Yoke, join with slip st in first ch 1, turn.

Next rnd: (RS) Ch 1, (sc, ch 1, dc) in each ch-sp around, join with slip st in first ch 1, turn. (48 [52, 60, 66, 68] clusters)

Sizes 2X and 3X only

Next rnd: (WS) Ch 1, (sc, ch 1, dc) in each ch-sp across back Yoke, ch [4, 6], (sc, ch 1, dc) in each ch-sp across front Yoke, ch [4, 6], join with slip st in first ch, turn.

Next rnd: (RS) Ch 1, ★sk first ch, (sc, ch 1, dc) in next ch, [sk next ch, (sc, ch 1, dc) in next ch] [once, twice] more, (sc, ch 1, dc) in next ch-sp across, to next connecting ch; rep from ★ around, join with slip st in first ch, turn. (74 [78] clusters)

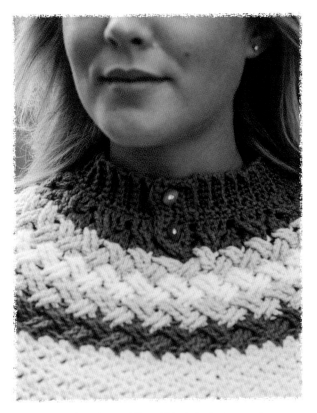

Instructions for only sizes XS and S include the button closure; the button closure ensures the sweater will fit over the wearer's head. The sweater may be worn with the buttons in the front or the back.

VICKI SWEATER MAIN STITCH

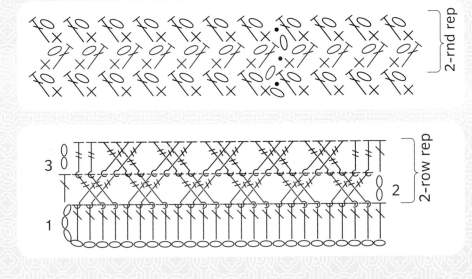

STITCH KEY

- • slip st
- ◯ chain (ch)
- ✕ single crochet (sc)
- ⊤ double crochet (dc)
- front post treble crochet (fptr)
- back post treble crochet (bptr)

Next 41 (41, 41, 41, 41, 43, 43) rnds: Ch 1, (sc, ch 1, dc) in each ch-sp around, join with slip st in first ch 1, turn.

BOTTOM RIBBING

Set-up rnd: (RS) Ch 1, 2 sc in each of next 3 ch-1 sps, 3 sc in each of next 21 (23, 27, 30, 31, 33, 36) ch-sps, 2 sc in each of next 3 ch-1 sps, 3 sc in each ch-sp around, join with slip st in first ch, do not turn. (138 [156, 174, 192, 210, 231, 249] sts)

Row 1: Ch 6, sc in 2nd ch from hook and in next 4 chs, slip st in each of next 2 sts from Set-up rnd, turn.

Row 2: Ch 1, sc BLO in next 5 sts, turn.

Row 3: Ch 1, sc BLO in next 5 sts, slip st in each of next 2 sts from Set-up rnd, turn.

Rep Rows 2 and 3 around bottom of body.

Work last row by joining to first set of 5 sc using slip sts. Fasten off.

COLLAR TRIM AND RIBBING

Sizes XS and S only

Set-up row for button opening: With RS facing, join at bottom of button opening on left side with a slip st, ch 1, work 4 sc evenly along opening to Collar foundation ch at top, ch 1, sc in same sp and in each ch of foundation ch. (DO NOT work on right side button opening.)

Do not fasten off.

Row 1: Ch 6, sc in 2nd ch from hook and in next 4 chs, slip st in each of next 2 sts from Set-up rnd, turn.

Row 2: Ch 1, sc BLO in next 5 sts, turn.

Row 3: Ch 1, sc BLO in next 5 sts, slip st in each of next 2 sts from Set-up rnd, turn.

Rep Rows 2 and 3 around neck opening.

Work last row by joining to first set of 5 sc using slip sts. Fasten off.

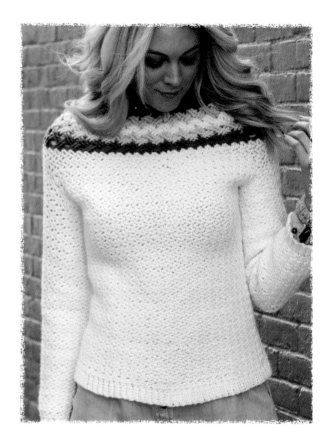

BACK BUTTON OPENING

Sizes XS and S only

Row 1: Work last row of ribbing, then continue working sc down left button opening and continuing up right side, working sc to top of ribbing, turn.

Row 2: Ch 1, sc in first st, ch 2, sk 2 (for first buttonhole), sc in next 4 sts, ch 2, sk 2 (for second buttonhole), sc in next 2 sts or to end of right side, turn.

Row 3: Ch 1, sc in 2 sc, 2 sc in ch-2 sp, sc in next 4 sts, 2 sc in ch-2 sp, sc in last st, turn.

Row 4: Ch 1, sc in each sc on right side of button opening, slip st in next st, fasten off.

Sew buttons in place.

Sizes M, L, XL, 2X, and 3X only

Set-up rnd: With RS facing, join with slip st at center Back neck, ch 1, sc in opposite side of each ch of foundation rnd, join with a slip st to first st of rnd.

Row 1: Ch 6, sc in 2nd ch from hook and in next 4 chs, slip st in each of next 2 sts from Set-up rnd, turn.

Row 2: Ch 1, sc BLO in next 5 sts, turn.

Row 3: Ch 1, sc BLO in next 5 sts, slip st in each of next 2 sts from Set-up rnd, turn.

Rep Rows 2 and 3 around bottom of body.

Work last row by joining to first set of 5 sc using slip sts. Fasten off.

SLEEVES

Note: The odd-numbered rounds will have the right side facing through Rnd 37.

Rnd 1: With RS facing, join with slip st in the center of the underarm, ch 1, sc in same place as joining, evenly work 35 (39, 39, 41, 45, 53, 57) more sc around arm. opening, join with slip st in first st of rnd, turn. (36 [40, 40, 42, 46, 54, 58] sts)

Rnd 2: Ch 1, ★(sc, ch 1, dc) in next sc, sk 1 sc; repeat from ★ around, slip st in first ch, turn. (18 [20, 20, 21, 23, 27, 29] clusters)

Rnd 3: Ch 1, (sc, ch 1, dc) in each ch-1 sp around, join with slip st in first ch, turn.

Rnds 4–29: Repeat Rnd 3.

Rnd 30: (First decrease rnd) Ch 1, (sc, ch 1, dc) in each ch-1 sp around to last ch-1 sp, sc in last ch-1 sp, join with slip st in first ch, turn.

Rnd 31: (2nd decrease rnd) Ch 1, sk first sc, (sc, ch 1, dc) in each ch-1 sp around, join with slip st in first ch, turn. (17 [19, 19, 20, 22, 26, 28] clusters)

Rnds 32–38: Repeat Rnd 3.

Rnd 39: Repeat Rnd 30. (16 [18, 18, 19, 21, 25, 27] clusters)

Rnd 40: Repeat Rnd 31.

Rnds 41–46: Repeat Rnd 3.

Rnd 47: Repeat Rnd 30. (15 [17, 17, 18, 20, 24, 26] clusters)

Rnd 48: Repeat Rnd 31.

Rnds 49–55: Repeat Rnd 3.

CUFF

Set-up rnd: Ch 1, 2 sc in each ch-1 sp around, join with slip st in first sc of rnd, do not turn.

Row 1: Ch 6, sc in 2nd ch from hook and in next 4 chs, slip st in each of next 2 sts from Set-up rnd, turn.

Row 2: Ch 1, sc BLO in next 5 sts, turn.

Row 3: Ch 1, sc BLO in next 5 sts, slip st in each of next 2 sts from Set-up rnd, turn.

Rep Rows 2 and 3 around bottom of sleeve.

Work last row by joining to first set of 5 sc using slip sts. Fasten off.

Weave in loose ends.

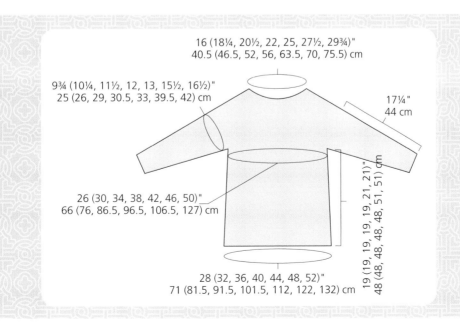

16 (18¼, 20½, 22, 25, 27½, 29¾)"
40.5 (46.5, 52, 56, 63.5, 70, 75.5) cm

9¾ (10¼, 11½, 12, 13, 15½, 16½)"
25 (26, 29, 30.5, 33, 39.5, 42) cm

17¼"
44 cm

26 (30, 34, 38, 42, 46, 50)"
66 (76, 86.5, 96.5, 106.5, 127) cm

19 (19, 19, 19, 19, 21, 21)"
48 (48, 48, 48, 48, 51, 51) cm

28 (32, 36, 40, 44, 48, 52)"
71 (81.5, 91.5, 101.5, 112, 122, 132) cm

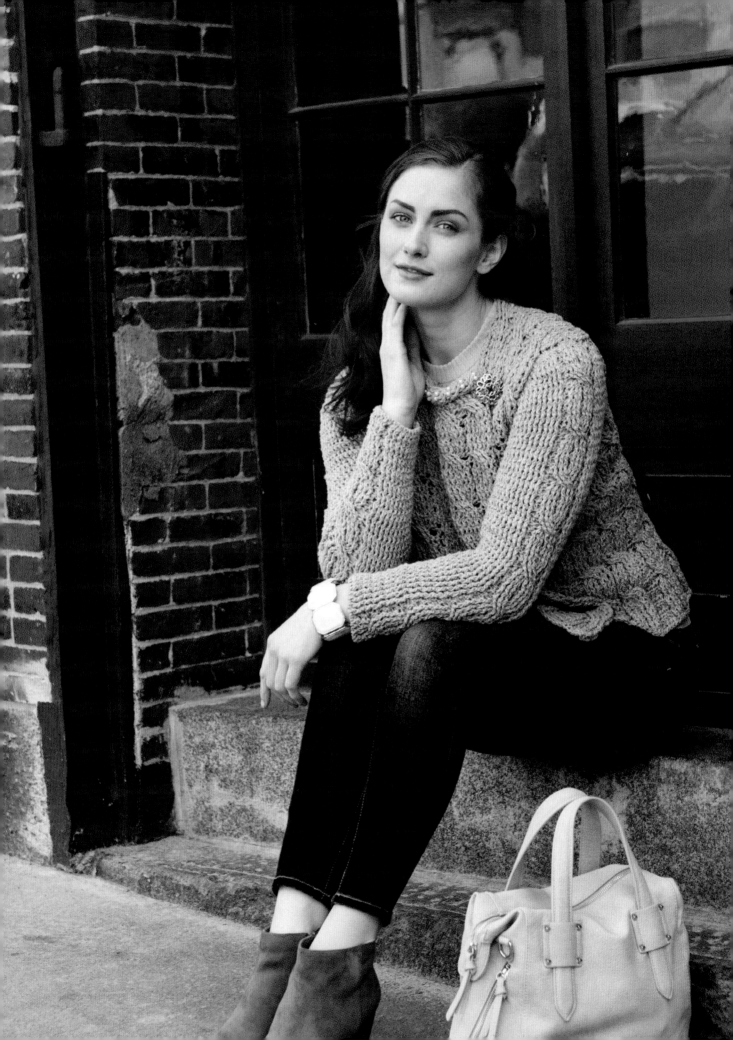

BINNE CARDIGAN

Binne, pronounced BEE-ne, is from the Old Irish *binn*, meaning sweet or melodious. Binne was the name of several fairy women in legend. The Binne Cardigan features an asymmetrical closure using your favorite brooch or shawl pin. Trimmed with a beaded cable collar and ruffle bottom that flatters any figure, it's one you'll want to add to your winter wardrobe.

SKILL LEVEL

Intermediate

YARN

DK (#3) weight.

Shown here: Cestari Collection (67% cotton, 25% wool, 8% silk; 250 yd [229 m]/100 g): #177006 Tropical Mist, 9 [9, 10, 11, 12, 13, 14] skeins.

HOOKS

Size H/8 (5 mm).

Adjust hook size if necessary to obtain gauge.

Size E/4 (3.5 mm).

NOTIONS

Approx. 40 pearl beads, size 6.

Shawl pin for closing front of sweater, optional.

Yarn needle.

SIZES/FINISHED DIMENSIONS

XS (S, M, L, XL, 2X, 3X). See schematics for specific measurements.

GAUGE

17 sts and 10 rows = 4" (10 cm) in fpdc with H/8 hook.

Gauge Swatch

Ch 23.

Row 1: Dc in 4th ch from hook and in each ch across.

Row 2: Ch 2, fpdc in next st and in each st across, hdc in turning ch.

Row 3: Ch 2, bpdc in next st and in each st across, hdc in turning ch.

Rows 4–12: Repeat Rows 2 and 3 as needed to check gauge.

SPECIAL STITCHES

Four-Stitch Post Cable, Large and Elongated Post Cable

PATTERN NOTES

Even-numbered rows will have the front side facing.

Turning chains do not count as stitches, but hdc working into turning chains does count as a stitch.

BACK

With larger hook, ch 60 (68, 76, 76, 84, 84, 84).

Row 1: Dc in 4th ch from hook and in each ch across, turn. (57 [65, 73, 73, 81, 81, 81] dc, not including turning ch)

Row 2: (RS) Ch 2, sk first st, [fpdc in next 3 sts, hdc in next st] across, ending with hdc in turning ch (here and throughout unless otherwise stated), turn.

Row 3: Ch 2, sk hdc, [bpdc in next 3 sts, hdc] across, turn.

Row 4: Ch 2, sk hdc, [sk next 3 sts, hdc in next hdc, fptr in next 3 sts, working in front of last 4 sts, fptr in 3 post sts just skipped, hdc in next hdc] across, turn.

Row 5: Ch 2, [3 bpdc, hdc in between last st and next st (or space in center of cable), 3 bpdc, hdc in next hdc] across, turn.

Rows 6–9: Repeat Rows 2 and 3 twice more.

Rows 10–15: Repeat Rows 4–9.

Rows 16–17 (17, 19, 19, 21, 21, 23): Repeat Rows 4–5 (5, 7, 7, 9, 9, 11).

Row 18 (18, 20, 20, 22, 22, 24): Ch 2, (1 dc, 1 hdc) in first st, work in established patt across to last hdc, (1 hdc, 1 dc, 1 hdc) in turning ch, turn. (61 [69, 77, 77, 85, 85, 85] sts)

Row 19 (19, 21, 21, 23, 23, 25): Ch 2, dc in first st, 2 dc in next st, hdc in next hdc, work in established patt across to last 3 sts, hdc in next hdc, 2 dc in next 2 sts, [dc, hdc] in turning ch, turn. (65 [73, 81, 81, 89, 89, 89] sts)

Row 20 (20, 22, 22, 24, 24, 26): Ch 2, 2 dc in first st, [dc, hdc] in next dc, 2 dc in next dc, dc in next dc, hdc in next hdc, work in established patt across, ending with [hdc, dc] in hdc, 2 dc in next dc, [hdc, dc] in next dc, 2 dc in next dc, dc in next 2 dc, hdc in turning ch, turn. (73 [81, 89, 89, 97, 97, 97] sts)

Sizes XS, S, M, L, and XL only

Rows 21–40 (21–40, 23–46, 23–46, 25–52): Work in established pattern, incorporating cable twists over new sts on both sides.

Sizes 2X and 3X only

Row (25, 27): Work even in established pattern, incorporating cable twists over new sts on both sides.

Rows (26–29, 28–31): Rep Rows (22–25, 24–27). (113 [113] sts)

Rows (30–52, 32–58): Work even in established patt, incorporating cable twists over new sts on both sides.

BOTTOM RUFFLE

Row 1: Ch 2, work next 7 cable sts as established, [2 hdc in next hdc, work next 7 cable sts as established] across to turning ch, hdc in turning ch, turn. (81 [90, 99, 99, 108, 126, 126] sts)

Row 2: Ch 2, work next 7 cable sts as established, [2 hdc in next hdc, hdc in next hdc, work next 7 cable sts as established] across to turning ch, hdc in turning ch, turn. (89 [99, 109, 109, 119, 139, 139] sts)

Row 3: Ch 2, work next 7 cable sts as established, [2 hdc in next hdc, hdc in next 2 sts, work next 7 cable sts as established] across to turning ch, hdc in turning ch, turn. (97 [108, 119, 119, 130, 152, 152] sts)

Rows 4 and 5: Ch 2, work next 7 cable sts as established, [4 hdc, work next 7 cable sts as established] across to turning ch, hdc in turning ch, turn.

Row 6: Ch 2, work next 7 cable sts as established, [2 hdc in next hdc, hdc in next 3 hdc, work next 7 cable sts as established] across to turning ch, hdc in turning ch, turn. (105 [117, 129, 129, 141, 165, 165] sts)

Rows 7–13: Ch 2, work next 7 cable sts as established, [5 hdc, work next 7 cable sts as established] across to turning ch, hdc in turning ch, turn.

RIGHT FRONT PANEL (Wider Panel)

With larger hook, ch 60 (68, 76, 84, 84, 92, 92).

Row 1: Dc in 4th ch from hook and in each ch across, turn. (57 [65, 73, 81, 81, 89, 89] dc, not including turning ch)

Rows 2–17: Work as for Back Rows 2–17.

Work next 3 (3, 3, 3, 3, 7, 7) rows of right side of Back shaping on right edge of work (to fit right armhole). (65 [73, 81, 89, 89, 105, 105] sts)

Work right armhole same as Back directions. Do not increase to left side of panel.

Work rows 1–13 of Bottom Ruffle. (101 [117, 129, 141, 141, 177, 177] sts)

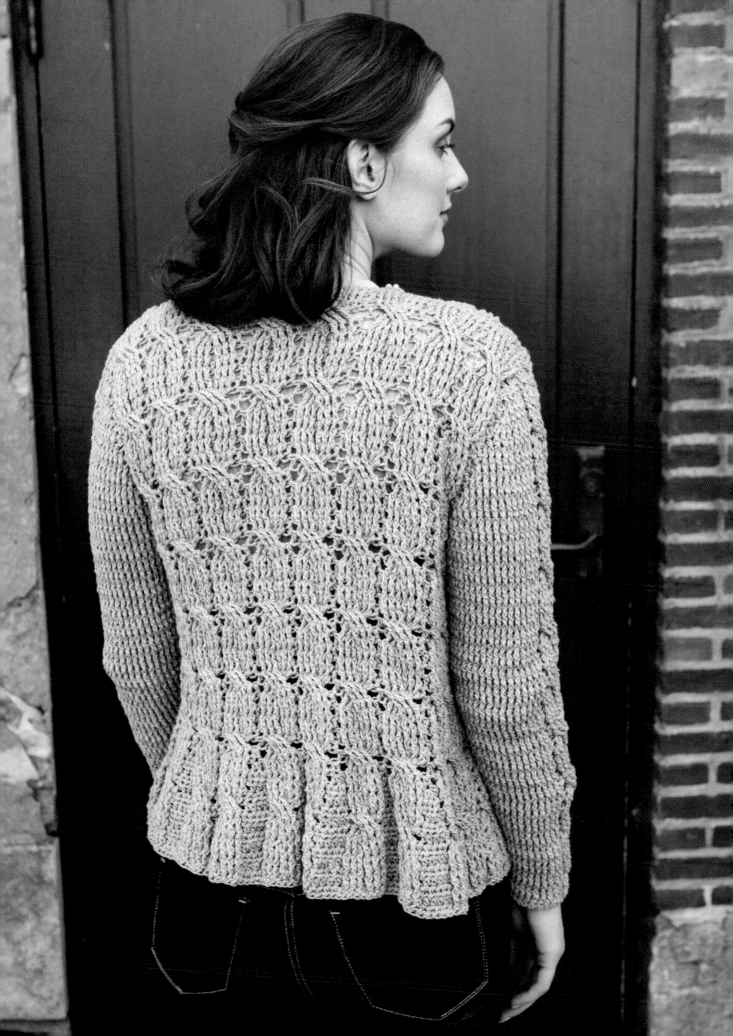

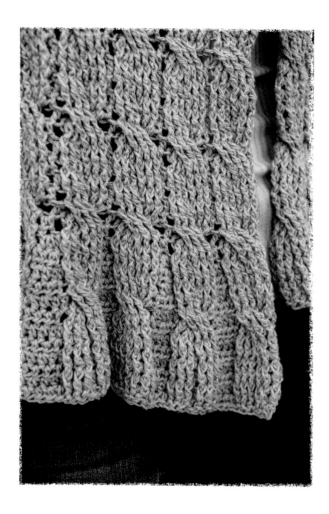

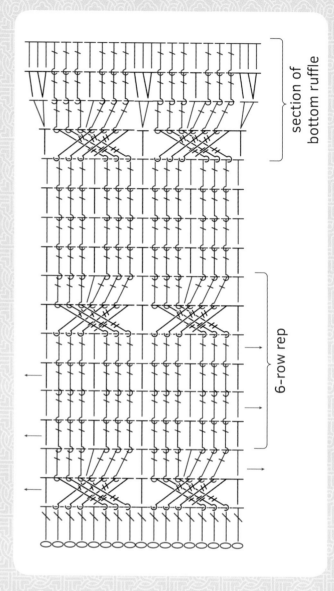

LEFT FRONT PANEL (Narrow Panel)

With larger hook, ch 28 (28, 28, 28, 28, 36, 36).

Row 1: Dc in 4th ch from hook and in each ch across, turn. (25 [25, 25, 25, 25, 33, 33] dc, not including turning ch)

Rows 2–17: Work as for Back Rows 2–17.

Work next 3 (3, 3, 3, 3, 7, 7) rows of right side of Back shaping on right edge of work. (33 [33, 33, 33, 33, 49, 49] sts)

Work left armhole same as Back directions. Do not increase to right side of panel.

Work rows 1–13 of Bottom Ruffle. (48 [48, 48, 48, 48, 69, 69] sts)

section of bottom ruffle

6-row rep

STITCH KEY

⬭ chain (ch)

| half double crochet (hdc)

⊤ double crochet (dc)

front post double crochet (fpdc)

back post double crochet (bpdc)

front post treble crochet (fptr)

→ indicates direction of rows or rounds

SLEEVES (Make 2)

Using larger hook, ch 33 (33, 33, 37, 37, 45, 53).

Row 1: Dc in 4th ch and each ch across, turn. (30 [30, 30, 34, 34, 42, 50] dc)

Row 2: (RS) Ch 2, sk first st, 10 (10, 10, 12, 12, 16, 20) fpdc, [hdc in next st, 3 fpdc] twice, hdc in next st, 10 (10, 10, 12, 12, 16, 20) fpdc, hdc in turning ch, turn. (30 [30, 30, 34, 34, 42, 50] sts)

Row 3: Ch 2, sk first st, 10 (10, 10, 12, 12, 16, 20) bpdc, [hdc in next st, 3 bpdc] twice, hdc in next st, 10 (10, 10, 12, 12, 16, 20) fpdc, hdc in turning ch.

Row 4: Ch 2, dc in st at base of ch-2 (inc made), 10 (10, 10, 12, 12, 16, 20) fpdc, hdc in next st, sk 3 sts, hdc in next st, 3 fptr over next 3 sts, working in front of last 4 sts, fptr in 3 skipped post sts, hdc in next st, 10 (10, 10, 12, 12, 16, 20) fpdc, (dc, hdc) in turning ch (inc made), turn. (32 [32, 32, 36, 36, 44, 52] sts)

Row 5: Ch 2, sk first st, 11 (11, 11, 13, 13, 17, 21) bpdc, hdc in next st, 3 bpdc, hdc between last st and next st (center of cable), 3 bpdc, sk next hdc, hdc in next hdc, 11 (11, 11, 13, 13, 17, 21) bpdc, hdc in turning ch, turn.

Row 6: Ch 2, work fpdc across to center 9 sts, work cable as established, fpdc across, ending with hdc in turning ch, turn.

Row 7: Ch 2, dc in st at base of ch-2, work bpdc across to center 9 sts, work cable as established, bpdc across to last st, (dc, hdc) in last st, turn. (34 [34, 34, 38, 38, 46, 54] sts)

Rows 8 and 9: Work in established patt across, turn.

Row 10: Ch 2, dc in st at base of ch-2, work fpdc across to center 9 sts, work cable as established, fpdc across to last st, (dc, hdc) in last st, turn. (36 [36, 36, 40, 40, 48, 56] sts)

Rows 11–13: Work in established patt across, turn.

Row 14: Rep Row 10. (30 [38, 38, 42, 42, 50, 58] sts)

Rows 15 and 16: Work in established patt across, turn.

Row 17: Rep Row 7. (40 [40, 40, 44, 44, 52, 60] sts)

Rows 18–20: Work in established patt across, turn.

Row 21: Rep Row 7. (42 [42, 42, 46, 46, 54, 62] sts)

Rows 22 and 23: Work in established patt across, turn.

Row 24: Rep Row 10. (44 [44, 44, 48, 48, 56, 64] sts)

Rows 25–27: Work in established patt across, turn.

Row 28: Rep Row 10. (46 [46, 46, 50, 50, 58, 66] sts)

Rows 29 and 30: Work in established patt across, turn.

Row 31: Rep Row 7. (48 [48, 48, 52, 52, 60, 68] sts)

Rows 32–34: Work in established patt across, turn.

Row 35: Rep Row 7. (50 [50, 50, 54, 54, 62, 70] sts)

Rows 36 and 37: Work in established patt across, turn.

Row 38: Rep Row 10. (52 [52, 52, 56, 56, 64, 72] sts)

Rows 39–41: Work in established patt across, turn.

Row 42: Rep Row 10. (54 [54, 54, 58, 58, 66, 74] sts)

Sizes XS, S, and M only

Skip remaining rows and begin Sleeve Cap.

Sizes L, XL, 2X, and 3X only

Rows 43 and 44: Work in established patt across, turn.

Sizes 2X and 3X only

Rows 45 and 46: Work in established patt across, turn.

SLEEVE CAP

All sizes

Row 1: Ch 1, sk first st, slip st in next 3 sts, hdc2tog in next 2 sts, work in pattern st to last 5 sts and turning ch, hdc2tog in next 2 sts, turn, leaving remaining sts unworked. (44 [44, 44, 48, 48, 56, 64] sts)

Row 2: Ch 1, hdc2tog in next 2 sts, work in pattern sts to last st and turning ch, hdc2tog in next 2 sts. (42 [42, 42, 46, 46, 54, 62] sts)

Rows 3–14: Repeat Row 2. Fasten off at the end of Row 14. (18 [18, 18, 22, 22, 30, 38] sts)

Sizes L, XL, 2X, 3X only

Rows 15 and 16: Repeat Row 2. (18 [18, 26, 34] sts)

Sizes 2X and 3X only

Rows 17 and 18: Repeat Row 2. Finish off. (22 [30] sts)

All sizes

Fasten off.

10¾ (12¾, 12¾, 13½, 13½, 15½, 17½)"
27.5 (32, 32, 34.5, 34.5, 39.5, 44.5) cm

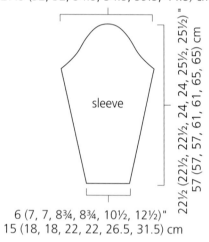

sleeve

22½ (22½, 22½, 24, 24, 25½, 25½)"
57 (57, 57, 61, 61, 65, 65) cm

6 (7, 7, 8¾, 8¾, 10½, 12½)"
15 (18, 18, 22, 22, 26.5, 31.5) cm

17 (17, 21, 21, 22¾, 22¾, 26½)"
43 (43, 53.5, 53.5, 58, 58, 67.5) cm

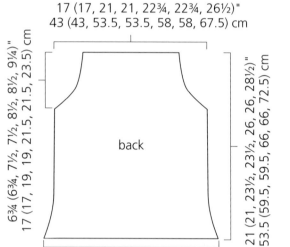

back

6¾ (6¾, 7½, 7½, 8½, 8½, 9¼)"
17 (17, 19, 19, 21.5, 21.5, 23.5) cm

21 (21, 23½, 23½, 26, 26, 28½)"
53.5 (53.5, 59.5, 59.5, 66, 66, 72.5) cm

17 (19, 21, 21, 23, 23, 23)"
43 (48.5, 53.5, 53.5, 58.5, 58.5, 58.5) cm

13½ (15, 17, 19, 19, 21, 21)"
34.5 (38, 43, 48.5, 48.5, 53.5, 53.5) cm

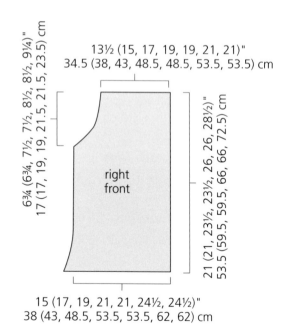

right
front

6¾ (6¾, 7½, 7½, 8½, 8½, 9¼)"
17 (17, 19, 19, 21.5, 21.5, 23.5) cm

21 (21, 23½, 23½, 26, 26, 28½)"
53.5 (53.5, 59.5, 59.5, 66, 66, 72.5) cm

15 (17, 19, 21, 21, 24½, 24½)"
38 (43, 48.5, 53.5, 53.5, 62, 62) cm

6 (6, 6, 6, 6, 8, 8)"
15 (15, 15, 15, 15, 20.5, 20.5) cm

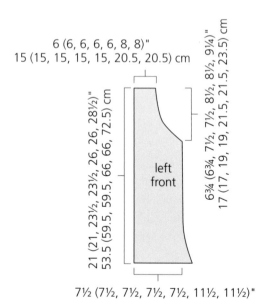

left
front

6¾ (6¾, 7½, 7½, 8½, 8½, 9¼)"
17 (17, 19, 19, 21.5, 21.5, 23.5) cm

21 (21, 23½, 23½, 26, 26, 28½)"
53.5 (53.5, 59.5, 59.5, 66, 66, 72.5) cm

7½ (7½, 7½, 7½, 7½, 11½, 11½)"
19 (19, 19, 19, 19, 29, 29) cm

FINISHING

Block sections of sweater if needed.
With RS facing, sew shoulder seams, joining both sides approx 3 cables wide at joining sites. Carefully line up and sew sleeves by centering cable to shoulder seam, easing in fabric as necessary to match armhole opening. After sleeve is sewn into place, sew sleeve and side seams.

NECK CABLE TRIM

Load 28 to 40 pearl beads onto source of yarn using a beading needle. (The number of beads needed will vary depending upon size and preference.)
Using smaller hook, ch 8.

Row 1: (WS) Dc in 4th ch from hook, dc a bead into next 2 sts as follows: [yo, insert hook into ch, pull up loop, yo, pull through 2 loops, drag 1 pearl into place, yo, pull through 2 loops. Bead should be secured and facing the back side during this row]. Dc in next ch, hdc in last ch, turn.
Row 2: Ch 2, sk first 3 sts, fptr in next two sts, being careful to crochet around bead so that it faces you securely. Working in front of the last 2 sts, fptr in the 2nd and 3rd skipped sts, dc in turning ch, turn.
Row 3: Ch 2, sk first st, bpdc in next st, bpdc a bead into next 2 sts (as per Row 1), bpdc in next st, hdc in turning ch, turn.
Repeat Rows 2 and 3 until cable measures the length from side of collar to end of large opened flap of sweater.
Last row: Fpdc across. Fasten off.
Using matching sewing thread, sew collar trim into place. Weave in loose ends.

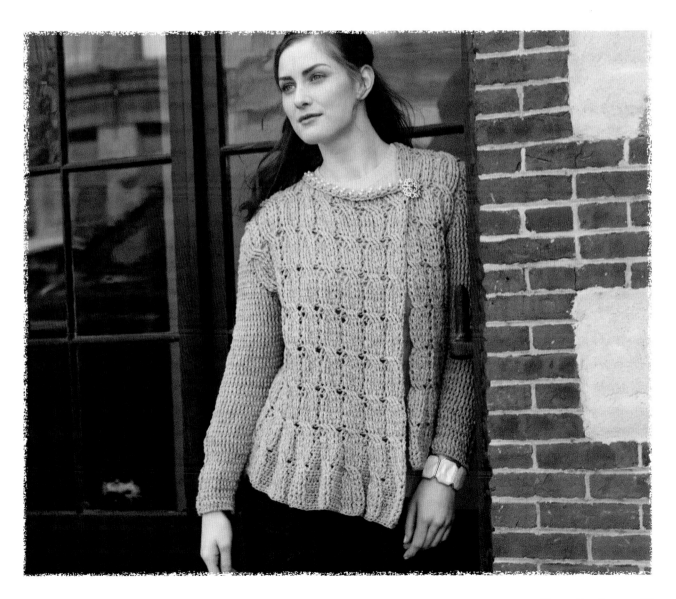

BLUE MOON SHAWL

This shawl/scarf is definitely one of my favorite designs to create. It features my new method of crocheting large cables plus an easy-to-learn lace cluster that I think you will come to love as well. Working with the kettle-dyed wool was an added special treat! You'll want a few of these in different colors to highlight your fall and winter wardrobes or give as a gift for that special friend!

SKILL LEVEL

Intermediate

YARN

Fingering (#1) weight.

Shown here: Malabrigo Sock (100% super-wash merino wool; 440 yd [402 m]/100 g): #806 Impressionist Sky, 2 hanks.

HOOKS

Size G/6 (4 mm).

Adjust hook size if necessary to obtain gauge.

NOTIONS

Yarn needle.

FINISHED DIMENSIONS

50" × 12" (127 × 30.5 cm).

GAUGE

7 lace clusters = 3" (7.5 cm), approx. 17 rows = 4" (10 cm).

SPECIAL STITCHES

Lace Cluster

[Sc, ch 1, dc] in ch-1 of previous row, or in every other st.

Large Honeycomb Cable

PATTERN NOTES

The even-numbered rows will have the front side facing.

SHAWL

Ch 254.

Row 1: Dc in 3rd ch and in each ch across, turn. (252 dc, not including turning ch)

Row 2: Ch 1, sc in first dc, [(sc, ch 1, dc—cluster made) in next st, sk next st] 9 times, ★[hdc in next st, fpdc in next 3 sts] 4 times, hdc in next st,★★ [(sc, ch 1, dc) in next st, sk next st] 8 times; repeat from ★ 5 times more, then repeat from ★ to ★★ once more; [(sc, ch 1, dc) in next st, sk next st] 9 times, sc in turning ch, turn. (66 clusters, 84 fpdc, 35 hdc, 2 sc)

Row 3: Ch 1, [(sc, ch 1, dc) in next ch-1 st] 9 times, ★[hdc in next st, bpdc in next 3 sts] 4 times, hdc in next st,★★ [(sc, ch 1, dc) in next ch-1 sp] 8 times; repeat from ★ 5 more times, then repeat from ★ to ★★ once more; [(sc, ch 1, dc) in next ch-1 st] 9 times, sc in turning ch, turn.

Note: From this row to Row 46, decreases will be made both at the beginning and at the end of each row. When working over lace clusters, decrease one cluster on each end as follows: At the beginning of the row, ch 1, sc in first ch-1 sp, then skip to next ch-1 sp and continue in cluster pattern stitch. At the end of the row, sc in last ch-1 sp and turn, leaving remaining sts unworked. When decreasing over cabled stitches, decrease over 2 sts by working a slip st in each of 2 end stitches at beg of row. At end of row, leave 2 sts unworked. Be sure to check each end so that the same number of sts remains at the ends for symmetry.

Row 4: (RS) Ch 1, sc in first ch-1 sp (decrease made), [(sc, ch 1, dc) in next ch-1 sp] across to first cable, ★hdc in next hdc, sk next 3 sts, hdc in next hdc, fptr in next 3 sts, working behind last 4 sts, fptr in first 3 skipped sts, hdc in next st, sk next 3 sts, hdc in next st, fptr in next 3 sts, working in front of last 4 sts, fptr in 3 skipped sts, hdc in next hdc, [(sc, ch 1, dc) in next ch-1 sp] 8 times, repeat from ★ across, ending final repeat after cable, [(sc, ch 1, dc) in next ch-1 sp] across to last ch-1 sp, sc in last ch-1 sp (decrease made), turn, leaving rem sts unworked. (64 clusters, 7 cables, 2 sc)

Row 5: Ch 1, sc in first ch-1 sp, [(sc, ch 1, dc) in next ch-1 sp] across to first cable, ★[hdc in next hdc, bpdc in next 3 sts, hdc between last st and next st (center of cable), bpdc in next 3 sts] 2 times, hdc in next hdc★★, [sk next st, (sc, ch 1, dc) in next st] 8 times; repeat from ★ across, ending final repeat at ★★, [(sc, ch 1, dc) in next ch-1 sp] across to last ch-1 sp, sc in last ch-1 sp, turn. (62 clusters, 7 cables, 2 sc)

Row 6: Ch 1, sc in first ch-1 sp, [(sc, ch 1, dc) in next ch-1 sp] across to first cable, ★[hdc in next hdc, fpdc in next 3 sts] 4 times, hdc in next hdc, ★★[(sc, ch 1, dc) in next ch-1 sp] 8 times; repeat from ★ across, ending final repeat at ★★, [(sc, ch 1, dc) in next ch-1 sp] across to last ch-1 sp, sc in last ch-1 sp, turn. (60 clusters, 7 cables, 2 sc)

Row 7: Ch 1, sc in first ch-1 sp, [(sc, ch 1, dc) in next ch-1 sp] across to first cable, ★[hdc in next hdc, bpdc in next 3 sts] 4 times, hdc in next hdc, ★★[sk next st, (sc, ch 1, dc) in next st] 8 times; repeat from ★ across, ending final repeat at ★★, [(sc, ch 1, dc) in next ch-1 sp] across to last ch-1 sp, sc in last ch-1 sp, turn. (58 clusters, 7 cables, 2 sc)

Row 8: Ch 1, sc in first ch-1 sp, [(sc, ch 1, dc) in next ch-1 sp] across to first cable, ★hdc in next hdc, sk next 3 sts, hdc in next st, fptr in next 3 sts, working in front of last 4 sts, fptr in first 3 skipped sts, hdc in next st, sk next 3 sts, hdc in next st, fptr in next 3 sts, working behind last 4 sts, fptr in 3 skipped sts, hdc in next hdc, ★★[(sc, ch 1, dc) in next ch-1 sp] 8 times; repeat from ★ across, ending final repeat at ★★, [(sc, ch 1, dc) in next ch-1 sp] across to last ch-1 sp, sc in last ch-1 sp, turn. (56 clusters, 7 cables, 2 sc)

Row 9: Ch 1, sc in first ch-1 sp, [(sc, ch 1, dc) in next ch-1 sp] across to first cable, ★[hdc in next hdc, bpdc in next 3 sts, hdc between last st and next st (center of cable), bpdc in next 3 sts] 2 times, hdc in next hdc, ★★[(sc, ch 1, dc) in next ch-1 sp] 8 times; repeat from ★ across, ending final repeat at ★★, [(sc, ch 1, dc) in next ch-1 sp] across to last ch-1 sp, sc in last ch-1 sp, turn. (54 clusters, 7 cables, 2 sc, 14 hdc)

Row 10: Ch 1, sc in first ch-1 sp, [(sc, ch 1, dc) in next ch-1 sp] across to first cable, ★[hdc in next hdc, fpdc in next 3 sts] 4 times, hdc in next hdc,★★ [(sc, ch 1, dc) in next ch-1 sp] 8 times; repeat from ★ across, ending final

repeat at ★★, [(sc, ch 1, dc) in next ch–1 sp] across to last ch–1 sp, sc in last ch–1 sp, turn. (52 clusters, 7 cables, 2 sc)

Row 11: Ch 1, sc in first ch–1 sp, (sc, ch 1, dc) in next ch–1 sp, ★[hdc in next hdc, bpdc in next 3 sts] 4 times, hdc in next hdc,★★ [sk next st, (sc, ch 1, dc) in next st] 8 times; repeat from ★ across, ending final repeat at ★★, (sc, ch 1, dc) in next ch–1 sp, sc in last ch–1 sp, turn. (50 clusters, 7 cables, 2 sc)

Row 12: Ch 1, slip st in 2nd and 3rd sts, work in established patt across to last 3 sts, turn, leaving rem sts unworked.

Row 13: Slip st in first 2 sts, work in established patt across to last 2 sts, turn, leaving rem sts unworked.

Rows 14–19: Repeat Row 13. (48 clusters, 5 cables)

Rows 20–35: Repeat Rows 4–19. (32 clusters, 3 cables)

Rows 36–43: Repeat Rows 4–11. (16 clusters, 3 cables)

Rows 44 and 45: Work even in patt without decreasing. Fasten off.

Be sure to check each end so that the same number of sts remains at the ends for symmetry.

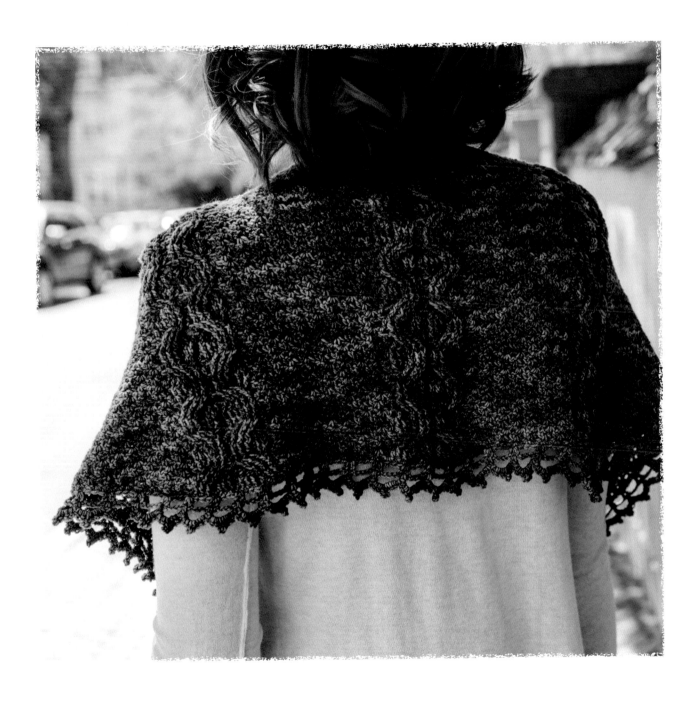

LACE EDGING

Row 1: With RS facing, join with slip st at lower right corner. Ch 1, work 290 sc evenly across curved side of shawl, turn.

Row 2: Ch 3, dc in first sc, [ch 3, sk 3 sts, 2 dc in next st] across to last 5 sts, ch 3, sk 4 sts, 2 dc in last sc, turn. (146 dc)

Row 3: Slip st in between 2 dc, ch 1, sc in same sp, [ch 5, sc in between next 2 dc] across, working last sc between dc and ch–3, turn. (73 sc)

Row 4: Ch 1, [3 sc, ch 3, slip st in 3rd ch from hook, 3 sc] in each ch-5 sp across. Slip st in last sc. Fasten off.

FINISHING

Weave in loose ends.

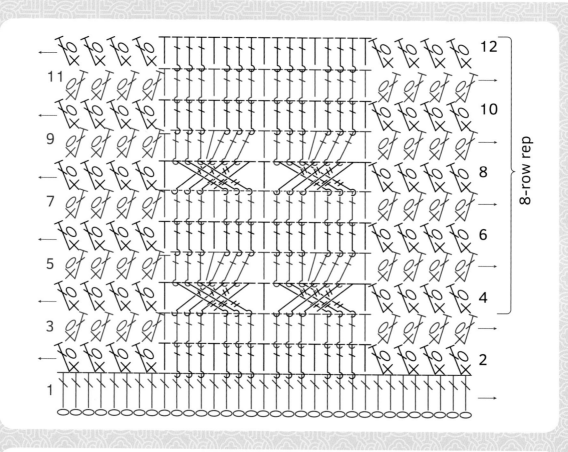

STITCH KEY

⬭ chain (ch)

✕ single crochet (sc)

⊤ half double crochet (hdc)

⊤ double crochet (dc)

⊤ front post double crochet (fpdc)

⊤ back post double crochet (bpdc)

⊤ front post treble crochet (fptr)

→ indicates direction of rows or rounds

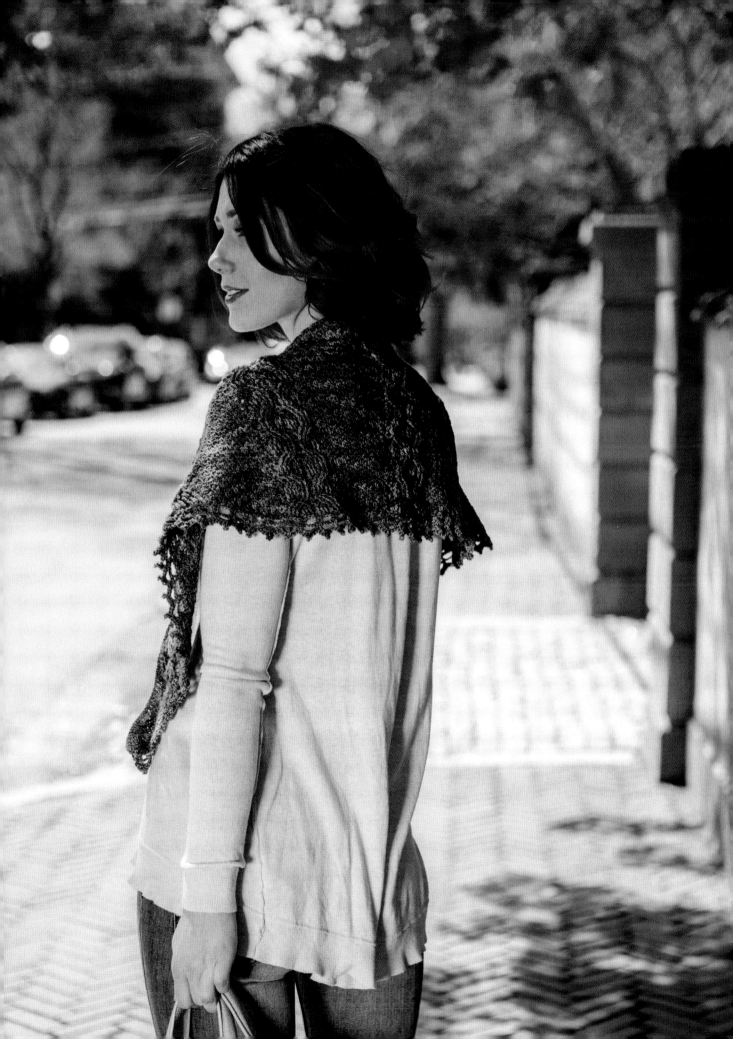

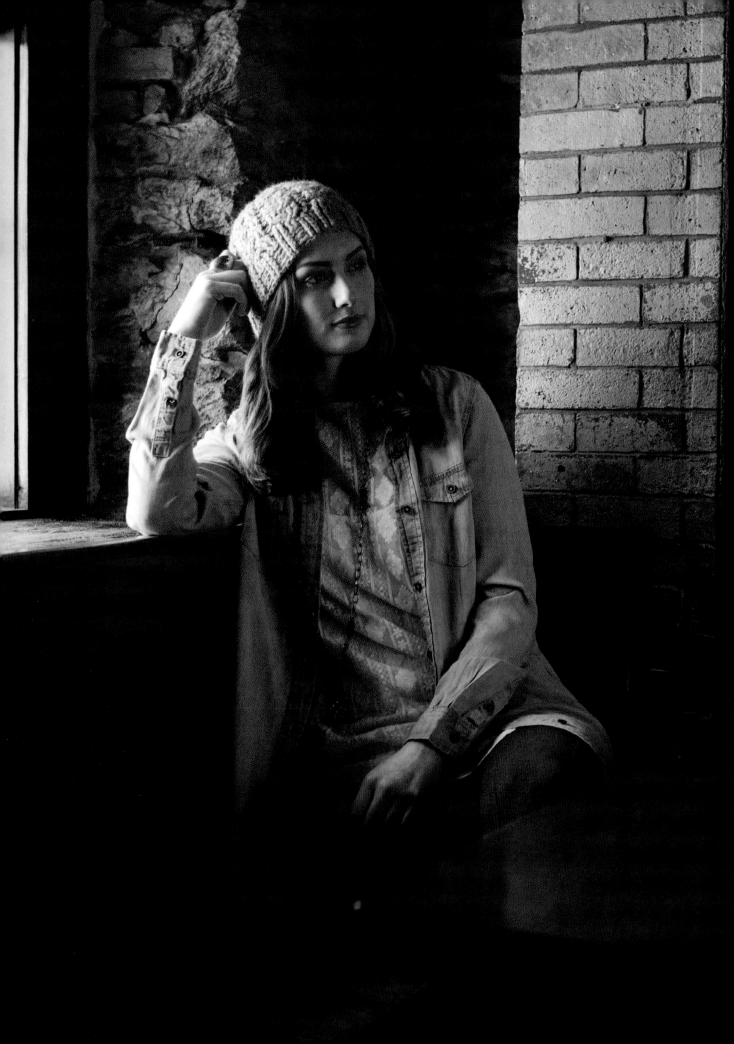

Stitch Abbreviations

approximately	approx	front post treble crochet	fptr
back loop(s)	blp(s)	half double crochet	hdc
back loop only	BLO	increase(s)	inc(s)
back post	bp	low back ridge	LBR
back post Braided Cable	bpBC	low front ridge	LFR
back post Celtic Weave	bpCW	main color	MC
back post double crochet	bpdc	previous	prev
back post treble crochet	bptr	remaining	rem
beginning	beg	repeat(s)	rep(s)
Braided Cable	BC	right side	RS
Celtic Weave	CW	round(s)	rnd(s)
chain	ch	single crochet	sc
chain space	ch sp	skip	sk
cluster	CL	slip stitch	slip st
continue	cont	space(s)	sp(s)
contrasting color	CC	stitch(es)	st(s)
decrease(s)	dec(s)	together	tog
double crochet	dc	treble crochet	tr
front loop(s)	flp(s)	Woven stitch	wv st
front post Braided Cable	fpBC	wrong side	WS
front post Celtic Weave	fpCW	yarn over	yo
front post double crochet	fpdc		

Foundation Stitches

If you're new to crochet or haven't crocheted in a while, review these foundation stitches before you dive into the special stitches (page 100) and the projects. The stitches you'll need to get started are shown first, followed by other basic stitches, shown from easiest to more complex.

SLIP KNOT

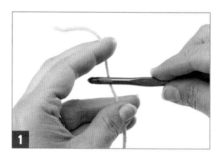

Holding the yarn with the small end up and the ball (or skein) down, place the hook as shown.

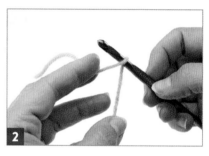

Push forward with the hook and twist to the left.

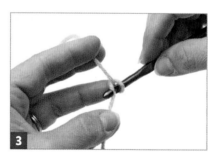

Place the long end over the back of the hook.

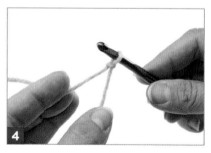

Gently pull through the lp and tighten by pulling on the small end of the yarn.

BEGINNING CHAIN (BEG CH)

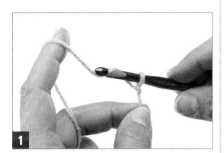

After forming a slip knot, yo the back of the hook.

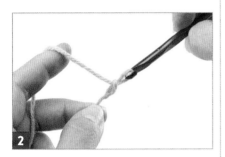

Pull through the lp.

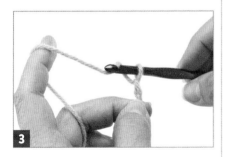

Yo again.

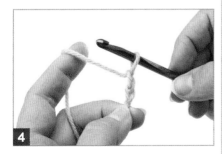

Pull through the lp. Cont to form a ch to the needed length.

SINGLE CROCHET (SC)

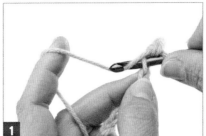

Working along a foundation ch, insert the hook into the 2nd ch from the hook.

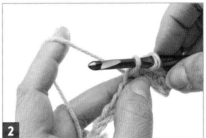

Pull up a lp.

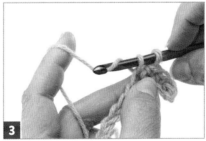

Yo the back of the hook.

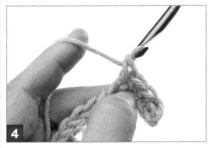

Pull through both lps on the hook. Sc completed.

SLIP STITCH (SLIP ST)

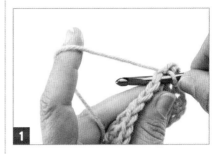

Insert the hook into both lps at the top of the st.

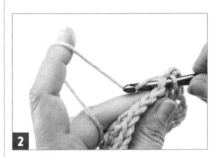

Yo.

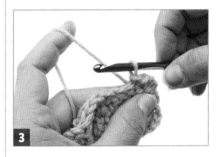

Pull through both lps.

DOUBLE CROCHET (DC)

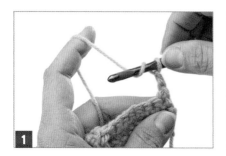

After completing a turning ch of 2 ch, yo.

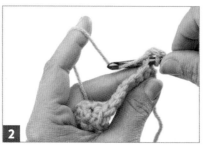

Insert the hook into the first st of the row (by going under both lps on top).

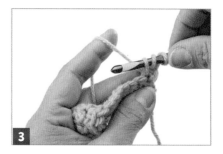

Pull up a lp.

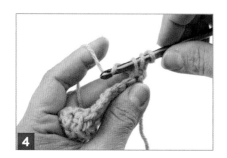

Yo the back of the hook.

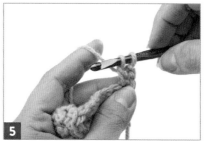

Pull through 2 lps.

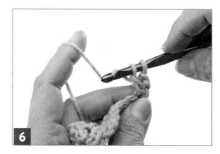

Yo and pull through both lps on the hook.

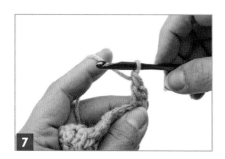

Dc complete.

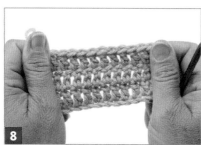

Sample of 3 dc rows.

FRONT POST DOUBLE CROCHET (FPDC)

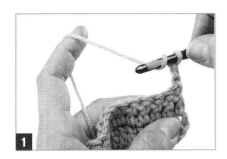

Starting from a turning ch of 2 ch, yo the back of the hook.

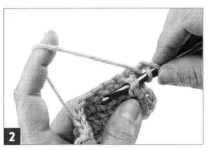

Starting in the 2nd dc from the edge, insert the hook around the body of the st until the hook comes out the other side.

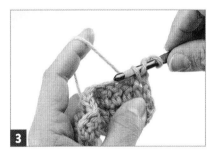

Yo and pull up a lp, yo the back of the hook.

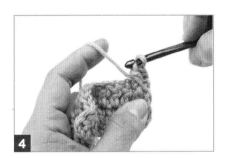

Pull through 2 lps.

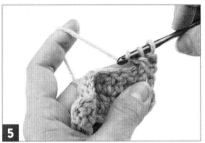

Yo and pull through 2 lps.

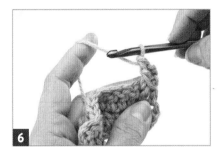

First fpdc completed.

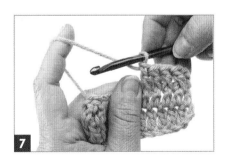

Several fpdc in a row.

BACK POST DOUBLE CROCHET (BPDC)

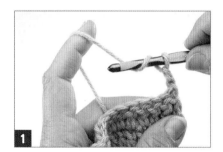

Yo.

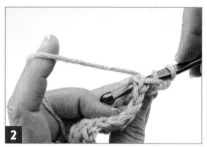

Insert the hook from the WS of the st toward the RS and then to the WS again.

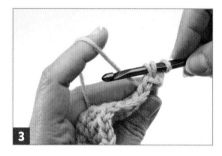

Pull up a lp.

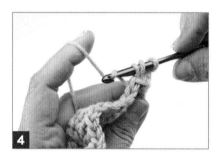

Yo the back of the hook.

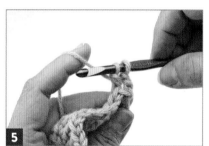

Pull through 2 lps on the hook.

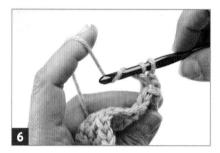

Yo and pull through both lps on the hook.

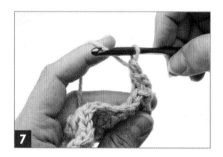

One bpdc is complete.

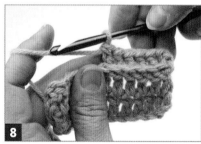

Several completed bpdc.

TREBLE CROCHET (TR)

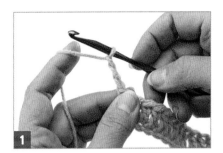

Ch 3.

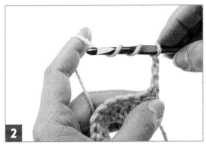

Yo the back of the hook twice.

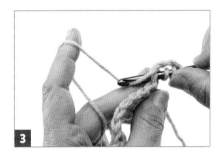

Insert the hook through the top lps of the st.

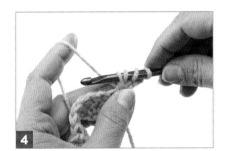

Pull up a lp.

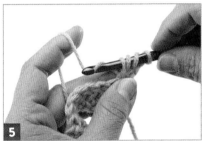

Yo the back of the hook.

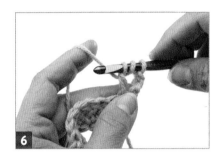

Pull through 2 lps.

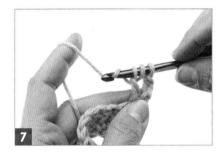

Yo the back of the hook.

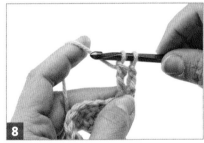

Pull through 2 lps for the 2nd time.

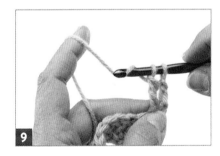

Yo the back of the hook.

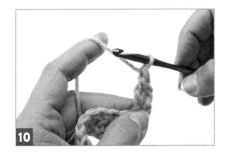

Pull through 2 lps for the 3rd time, completing the st.

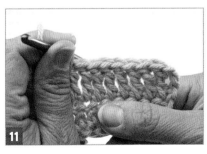

Sample of tr sts.

FRONT POST TREBLE CROCHET (FPTR)

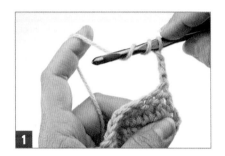

Yo the back of the hook twice.

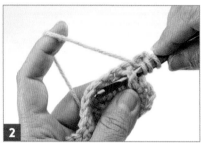

Starting in the 2nd tr from the edge, insert the hook around the body of the st until the hook comes out the other side.

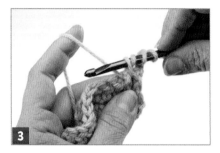

Yo and pull up a lp.

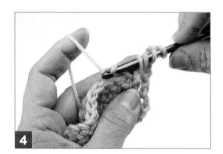

Yo and pull through 2 lps.

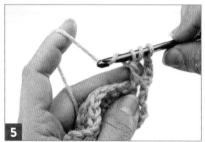

Yo and pull through 2 lps.

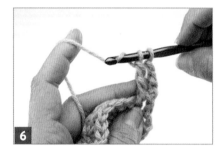

Yo and pull though 2 lps.

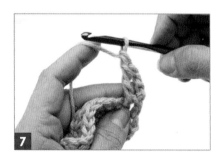

Completed fptr.

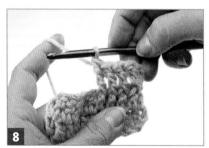

Several fptr in a row.

BACK POST TREBLE CROCHET (BPTR)

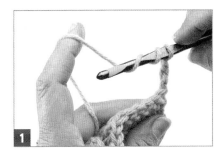

Yo twice.

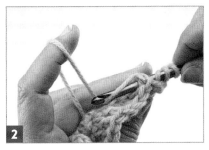

Insert the hook from the WS of the st toward the RS and then to the WS again.

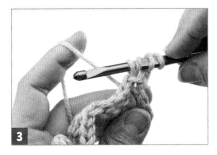

Pull up a lp.

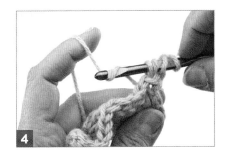

Yo the back of the hook.

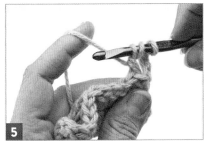

Pull through 2 lps.

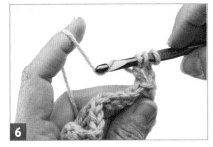

Yo the back of the hook.

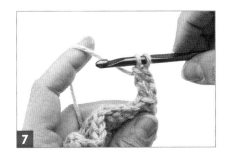

Pull through 2 lps.

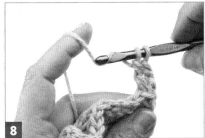

Yo the back of the hook.

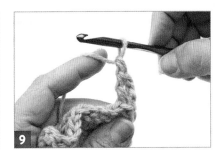

Pull through 2 lps, bptr completed.

Special Stitches

These are the speecial stitches you'll need to know to create the cables and designs in this book. They appear here in alphabetical order for easy reference.

ARROW/REVERSE ARROW

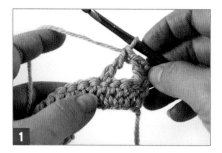

Row 1: Ch 2, dc in first st, * sk 3 sts, tr in next st.

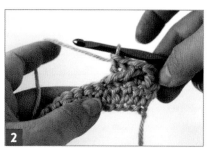

Working behind tr, dc in each of 3 skipped sts.

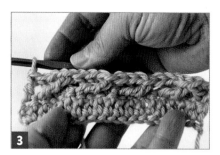

Repeat from * across row (or as needed), ending with a dc in last st or turning ch, depending on pattern. Turn.

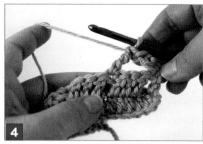

Row 2: Ch 2, dc in first st, *sk 3 sts, tr in next st.

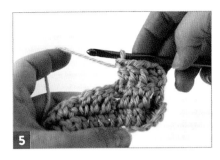

Working in front of tr, dc in each of 3 skipped sts.

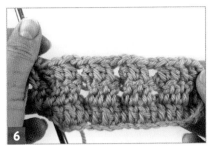

Repeat from * across row (or as needed), ending with a dc in last st or turning ch, depending on pattern. Turn.

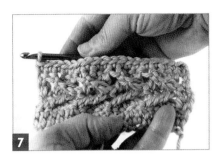

Row 3: Ch 1, sc in each st across. Turn.

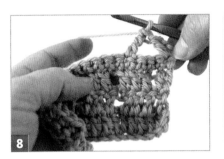

Row 4: Ch 2, dc in first st, **sk 3 sts, tr in next st.

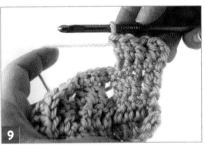

Working in front of tr, dc in each of 3 skipped sts.

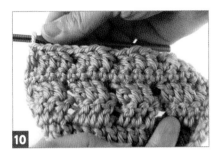

Repeat from ** across row (or as needed), ending with a dc in last st or turning ch, depending on pattern. Turn.

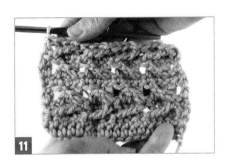

Row 5: Ch 2, dc in first st, ***sk 3 sts, tr in next st. Working behind tr, dc in each of 3 skipped sts. Repeat from *** across (or as needed), ending with a dc in last st or turning ch, depending on pattern. Turn.
Row 6: Repeat Row 3.

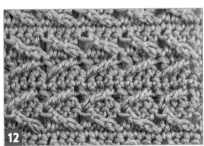

Repeat Rows 1–6 to continue stitch pattern. Completed example of Arrow st.

BIG BRAIDED CABLE (MULTIPLE OF 9 STS)

Row 1: (Worked onto a row of hdc, dc, or tr) Ch 3, sk first 4 sts *(sk only next 3 sts on repeats), fptr in next 3 sts.

Working in front of last 3 sts, fptr in last 3 skipped sts (do not work first st of row).

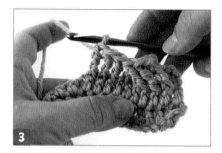

Fptr in next 3 sts.

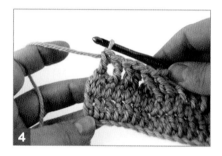

Repeat from * across, dc in last st or turning ch, depending on pattern instructions. Turn.

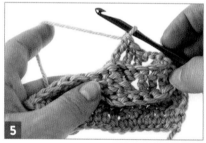

Row 2: Ch 3, sk first 4 sts **(sk only next 3 sts on repeats), bptr in next 3 sts.

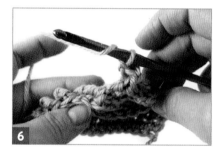

Working in front of last 3 sts (will cross in front on right side), bptr in last 3 skipped sts (do not work first st of row).

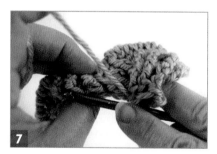

View of front side after Step 6.

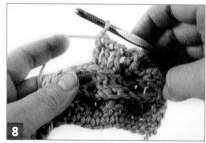

Bptr in next 3 sts. Repeat from ** across row, ending by working a dc in last st or turning ch, depending on pattern instructions. Turn.

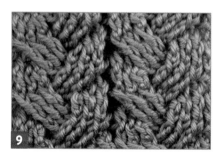

Repeat Rows 1 and 2 to establish pattern. Completed example of st.

BRAIDED CABLE (MULTIPLE OF 6 STS + 2)

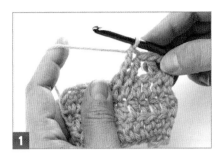

Row 1: (Worked onto a row of hdc, dc, or tr) Ch 3, sk first 3 sts *(sk only next 2 sts on repeats), fptr in next 2 sts.

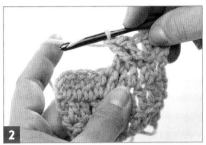

Working in front of last 2 sts, fptr in last 2 skipped sts (do not work first st of row).

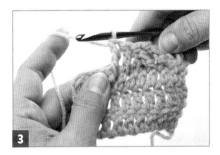

Fptr in next 2 sts. Repeat from * across, dc in last st or turning ch, depending on pattern instructions. Turn.

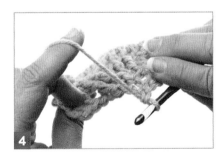

Row 2: Ch 3, sk first 3 sts **(sk only next 2 sts on repeats), bptr in next 2 sts.

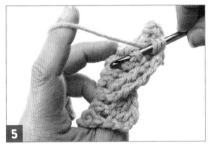

Working in front of last 2 sts (will cross in front on right side), bptr in last 2 skipped sts (do not work first st of row).

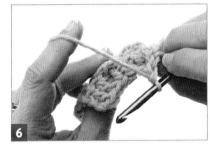

Bptr in next 2 sts. Repeat from ** across row, ending by working a dc in last st or turning ch, depending on pattern instructions. Turn.

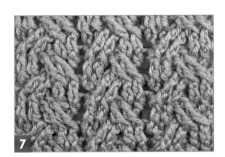

Completed braids shown from the WS.

BUTTONHOLES

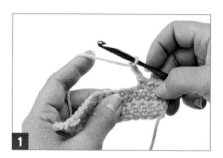

Row 1: At the proper place, ch 2, then sk the next 2 sts of the row.

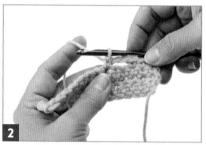

Sc in the next st. You should have formed a hole 2 sts wide in your work.

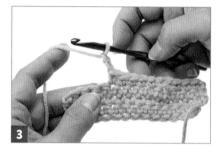

Sc the desired distance from the buttonhole just made to the beg of the next buttonhole. Ch 2, sk 2 sts, sc in the next st.

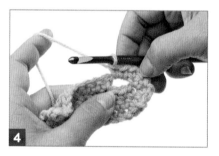

Row 2: Sc until you reach the ch-2 sp. *Work 2 sc in the ch-2 sp.

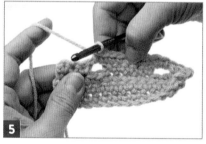

Sc in each st to the next ch-2 sp. Work 2 sc in the next ch-2 sp.

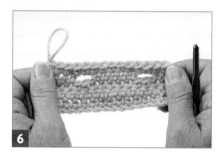

Completed example of buttonholes.

CABLE (MULTIPLE OF 3 STS + 2)

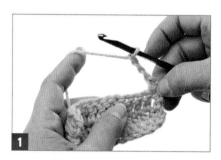

Row 1: *Sc in the first st of the row (or next st for repeats), ch 3.

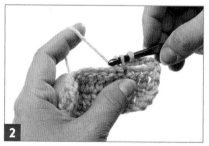

Sk the next 2 unworked sc of the prev row, sc in the next sc.

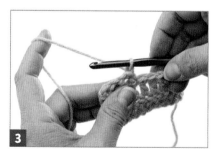

Turn.

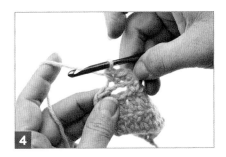

Work sc in each ch of the ch-3 just made.

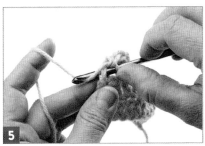

Sl st in the next sc.

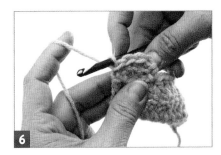

One cable made.

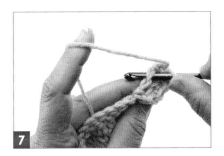

Turn. Working behind the cable, sc in each of the 2 skipped sc.

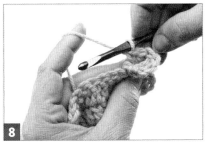

2 sc behind cable completed.

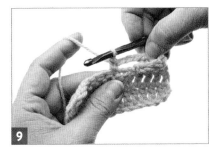

Ch 3, sk the next 2 unworked sc, rep from * across row. End by working a sc in the last sc or ch, depending on pattern instructions, of the row.

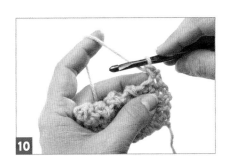

Row 2: Sc in the first sc.
Note: *In this row, you will work a sc in the first and last st, and 3 sc evenly spaced behind each cable (on the WS). The 3 sc behind each cable are worked into the 2 sc that were skipped in the previous row. Work a sc in one of these skipped sc and 2 sc into the other. Do not work into the sc of the cables. Push the cables toward the RS of your project as you work.*

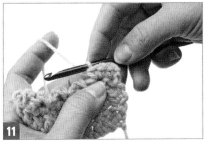

2 sc in the next sc (see the note in Step 10).

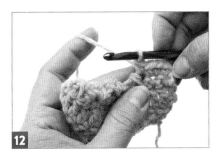

1 sc in the next sc. (There should be 3 sc behind the first cable, not including the first st of the row.)

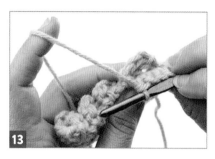

Another view of working a sc behind the cables.

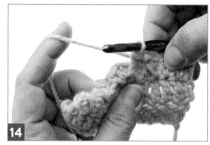

2 sc in the next sc.

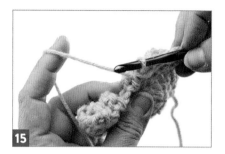

1 sc in the next sc. Cont across the row.

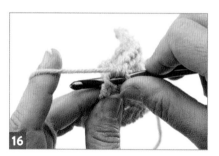

Sc in the last st of the row.

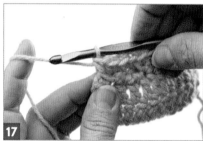

Back view of Cable st.

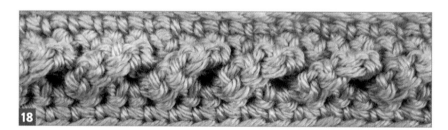

Completed example of Cable st.

CELTIC WEAVE (MULTIPLE OF 4 STS)

Row 1: With RS facing, ch 2, sk the first 3 sts. Fptr around the next st.

Working in front of the last 2 sts, fptr around the last 2 skipped sts.

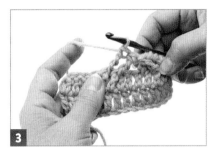

* Sk 2 sts, fptr around the next 2 sts.

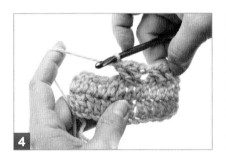

Working in front of the last 2 sts, fptr around the 2 skipped sts. Repeat from * across row as needed. Dc in turning ch, turn.

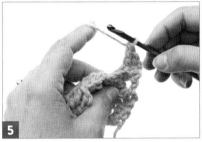

Row 2: Ch 2. With WS facing, bptr in each of the next 2 sts.

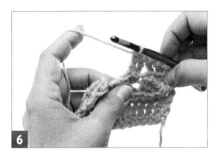

* Sk 2 sts, bptr around each of the next 2 sts.

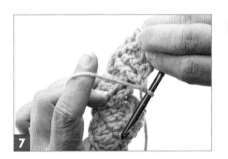

Working in front of the last 2 sts (will cross in front on right side), bptr around each of the 2 skipped sts. Repeat from * across or as needed. End by working a dc in the last st or turning ch.

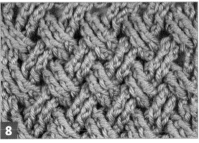

Completed example of Celtic Weave st.

TIP

..........................

Since it's much easier to feel these stitches than it is to see them, you may find it helpful to use the thumb and fingers of the hand holding the yarn to help guide your hook to the two stitches in Step 7.

FOUR-STITCH POST CABLE (MULTIPLE OF 4 STS)

Note: This stitch can be worked using dc or tr on Row 1, depending on the specific pattern.
Be sure to follow your instructions. Instructions below are demonstrated using tr in Row 1.

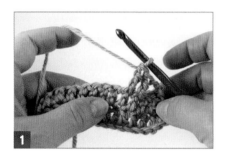

Row 1: Ch 2, sk first 3 sts *(sk only 2 sts on repeats), fptr in next 2 sts.

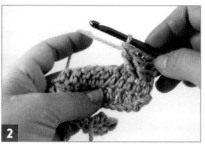

Working in front of last 2 sts, fptr in last 2 skipped sts (do not work first st of row).

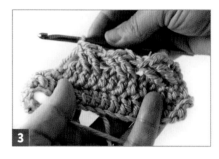

Repeat from * across row.

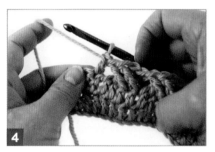

End by working a dc in last st or turning ch.

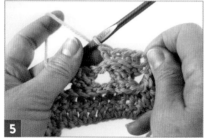

Row 2: Bpdc in next st (do not work first st of row) and in each st across row.

Hdc in last st or turning ch, depending on pattern instructions. Turn. Repeat Rows 1 and 2 to establish cable pattern.

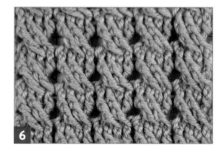

Completed example of Four-Stitch Post Cable.

HONEYCOMB CABLE

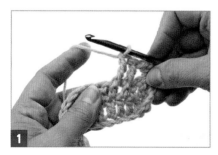

Row 1: Starting at the beg of the row, sk the first 3 sts, * (sk only 2 sts on repeats), fptr in each of the next 2 sts.

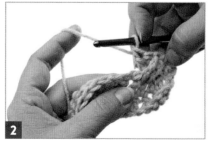

Working behind the last 2 sts, fptr in each of the 2 skipped sts.

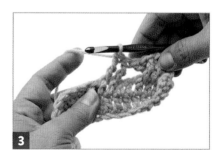

Sk 2 sts, fptr in each of the next 2 sts.

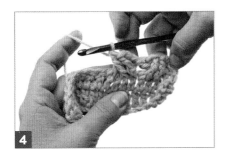

Working in front of the last 2 sts, fptr in each of the 2 skipped sts. Repeat from * across row as needed.

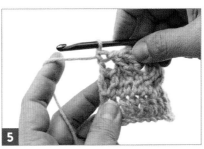

At the end of the row, dc in the last st or turning ch, depending on pattern. Turn.

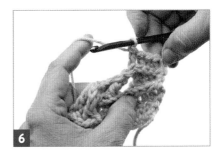

Row 2: Ch 2, beg in the 2nd st of the row, bpdc in each st across row. Dc or hdc, depending on pattern instructions, in last st or turning ch. Turn.

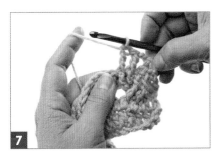

Row 3: Sk the first 3 sts, * (sk only 2 sts on repeats), fptr in each of the next 2 sts.

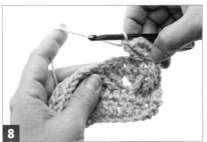

Working in front of the last 2 sts, fptr in the last 2 skipped sts.

Sk the next 2 sts, fptr in the next 2 sts.

Working behind the last 2 sts, fptr in the 2 skipped sts. Repeat from * across row as needed. Dc in the last st or turning ch.

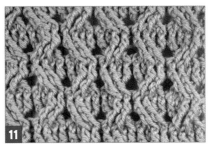

Completed example of Honeycomb Cable pattern.

KNURL (REVERSE SC)

Row 1: (This row will be worked left to right.) Working only in the front lp of the prev sc row, sk the first sc and insert the hook into the next sc (to the right of the hook).

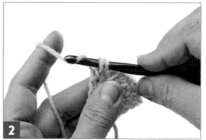

Hook the yarn and pull through to the left of the lp on the hook. Yo the back of the hook.

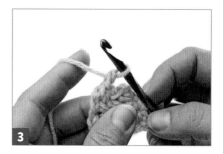

Pull through both lps on the hook (1 knurl completed).

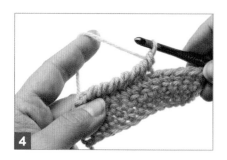

Rep in each sc across the row to the last sc.

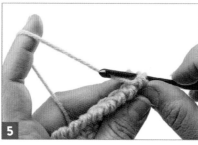

Slip st in the last sc.

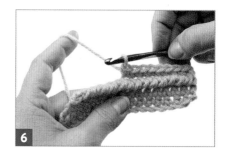

Row 2: Working from right to left and in the rem lp, sc in first and in each of the rem lps across row.

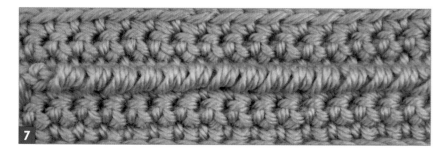

Completed example of Knurl st.

LARGE HONEYCOMB CABLE (MULTIPLE OF 17 STS)

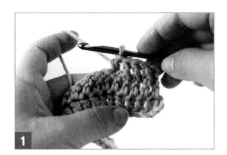

Row 1: *Hdc in first st, fpdc in each of next 3 sts.

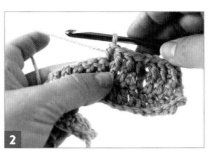

Repeat from * across row, hdc in last st or turning ch, depending on pattern instructions. Turn.

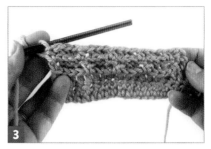

Row 2: Ch 2, *hdc in hdc, bpdc in each of next 3 sts. Repeat from * across. Hdc in last st or turning ch, depending on specific instructions. Turn.

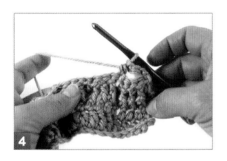

Row 3: Ch 2, **hdc in first st, sk next 3 post sts, hdc in next hdc.

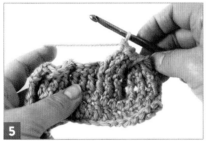

Fptr in each of next 3 sts. Working behind last 4 sts, fptr in 3 post sts just skipped.

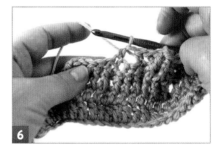

Hdc in next hdc, sk 3 post sts, hdc in next hdc.

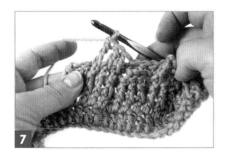

Fptr in each of next 3 sts.

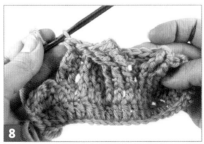

Working in front of last 3 sts, fptr in 3 skipped post sts. Repeat from ** across, or as needed for specific pattern, ending by working a hdc in next st. Turn.

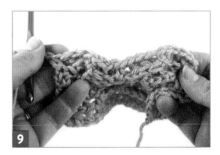

Row 4: Hdc in first st (hdc), *** bpdc in each of next 3 sts, hdc in between last st and next st (center of cable), bpdc in each of next 3 sts, hdc in next hdc, repeat from *** once more. Hdc in next (or last) st. Turn.

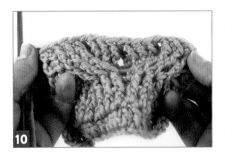

Row 5: Ch 2, [hdc in first hdc, fpdc in each of next 3 sts, hdc in next hdc] four times. Hdc in next (or last) st. Turn.

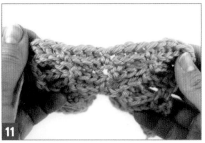

Row 6: Ch 2, [hdc in first hdc, bpdc in each of next 3 sts, hdc in next hdc] four times. Hdc in next (or last) st. Turn.

(For a more elongated Honeycomb Cable, repeat Rows 5 and 6 as needed.)

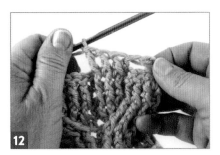

Row 7: Hdc in first hdc, sk next 3 post sts, hdc in next hdc, fptr in each of next 3 post sts.

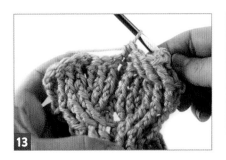

Working in front of last 4 sts, fptr in last 3 skipped sts, hdc in next hdc.

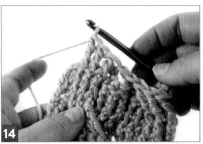

Skip next 3 post sts, hdc in next hdc, fptr in each of next 3 post sts.

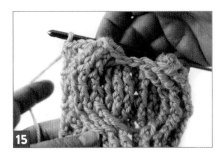

Working behind last 4 sts, fptr in each of the 3 skipped post sts. Hdc in next hdc. Turn.

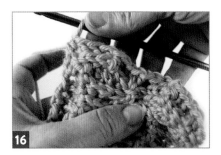

Row 8: Hdc in first st (hdc), ***bpdc in each of next 3 sts, hdc in between last st and next st (center of cable), bpdc in each of next 3 sts, hdc in next hdc, repeat from *** once more. Hdc in next (or last) st. Turn.

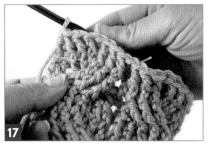

Row 9: Ch 2, [hdc in first hdc, fpdc in each of next 3 sts, hdc in next hdc] four times. Hdc in next (or last) st.

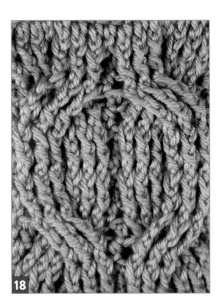

Completed example of Large Honeycomb Cable.

LARGE AND ELONGATED POST CABLE

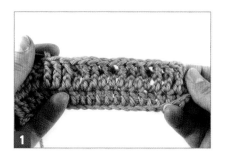

Row 1: (Worked into a row of hdc or dc) Ch 2, hdc into first st, [fpdc in each of next 3 sts, hdc in next st] across or as needed per pattern instructions. Turn.

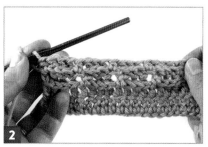

Row 2: Ch 2, hdc in first hdc, [bpdc in each of next 3 sts, hdc in next hdc] four times. Hdc in next (or last) st. Turn.

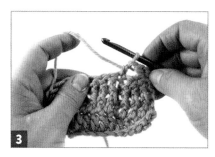

Row 3: Ch 2, * hdc in first st, sk next 3 post sts, hdc in next hdc.

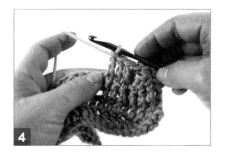

Fptr in each of next 3 post sts.

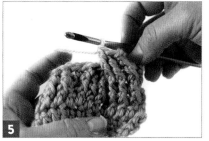

Working in front of last 4 sts worked, fptr in 3 skipped sts. Repeat from * as needed for more cables across row. End by working dc in last st or in turning ch. Turn.

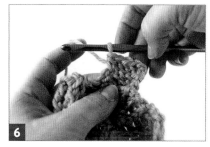

Row 4: Ch 2, hdc in first hdc, bpdc in each of next 3 post sts, hdc in between last st and next st (center of cable).

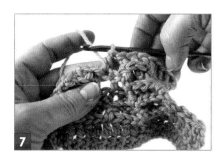

[Bpdc in each of next 3 post sts, hdc in next hdc] across row as needed per pattern instructions. Hdc in last st or turning ch. Turn.

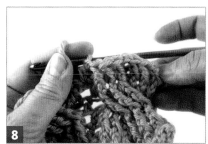

Row 5: Ch 2, [hdc in first hdc, fpdc in each of next 3 sts, hdc in next hdc] across row as needed. Hdc in next (or last) st. Turn.

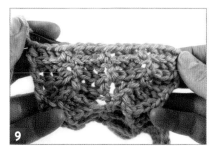

Row 6: Ch 2, hdc in first hdc, [bpdc in each of next 3 sts, hdc in next hdc] across row as needed. Hdc in next (or last) st. Turn.

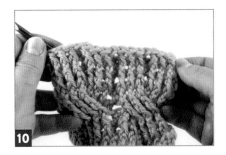

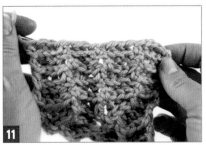

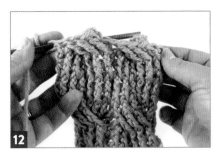

Row 7: Ch 2, hdc in first hdc, [fpdc in each of next 3 sts, hdc in next hdc] across row as needed. Hdc in next (or last) st. Turn.

Row 8: Ch 2, hdc in first hdc, [bpdc in each of next 3 sts, hdc in next hdc] across row as needed. Hdc in next (or last) st. Turn.

Repeat Row 3 above.

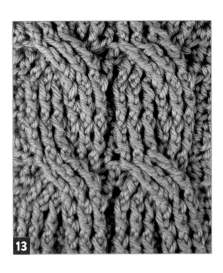

Completed example of Large Elongated Post Cable.

LARGE WHEAT CABLE

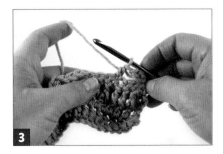

Row 1: (Worked into a row of hdc or dc) Ch 2, * [hdc in first st, fpdc in each of the next 3 sts] four times. Repeat from * as needed per pattern instructions. Hdc in last st or turning ch. Turn.

Row 2: Ch 2, hdc in first hdc, [bpdc in each of next 3 sts, hdc in next hdc] across row as needed. Hdc in next (or last) st. Turn.

Row 3: Ch 2, *hdc in first hdc, sk next 3 post sts, hdc in next hdc.

Fptr in next 3 post sts, working behind last 4 sts worked, fptr in 3 skipped post sts.

Hdc in next hdc, sk next 3 sts, hdc in next hdc.

Fptr in next 3 post sts.

Working in front of last 4 sts, fptr in 3 skipped post sts. Repeat from * across row or as needed. Turn.

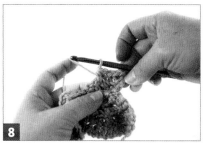

Row 4: Ch 2, hdc in hdc, **bpdc in each of the next 3 post sts, hdc in between the last st and the next st.

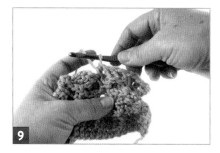

Bpdc in each of the next 3 post sts, hdc in next hdc.

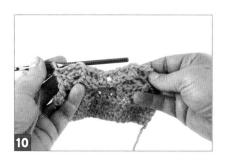

Repeat from ** once more to complete cable.

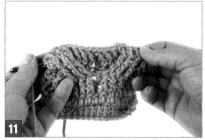

Row 5: Ch 2, *[hdc in first st, fpdc in each of the next 3 sts] four times. Repeat from * as needed per pattern instructions. Hdc in last st or turning ch, depending on pattern. Turn.

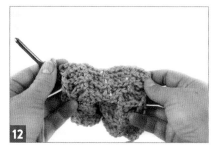

Row 6: Ch 2, hdc in first hdc, [bpdc in each of next 3 sts, hdc in next hdc] across row as needed. Hdc in next (or last) st. Turn.

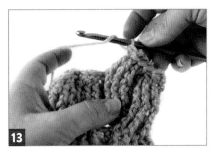
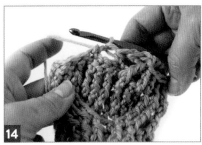
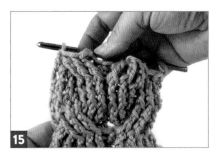

Row 7: Ch 2, *hdc in first hdc, sk next 3 post sts, hdc in next hdc. Fptr in next 3 post sts, working behind last 4 sts worked, fptr in 3 skipped post sts.

Hdc in next hdc, sk next 3 post sts, hdc in next hdc.

Fptr in next 3 post sts. Working in front of last 4 sts, fptr in 3 skipped post sts. Repeat from * across row or as needed. Turn. Repeat Rows 1–7 as needed or as per instructions.

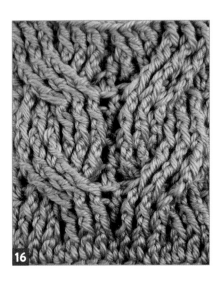

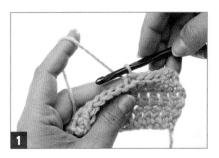

Completed example of Large Wheat Cable.

LOW BACK RIDGE (LBR)

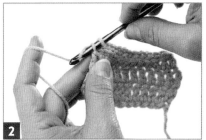
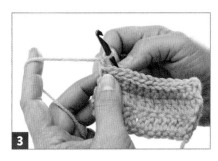

Row 1: Working in the back loops only, and with the WS facing, sk the first st of the row and slip st in the next sc and in each sc across the row.

Slip st in 1 lp of turning ch, turn.

Ch 1.

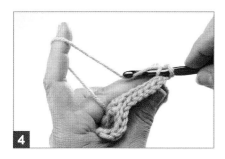

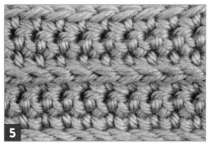

Row 2: Working in the rem lp of the sc, sk the turning ch, sc in the first sc of the row and in each sc across.

Completed example of Low Back Ridge.

LOW FRONT RIDGE (LFR)

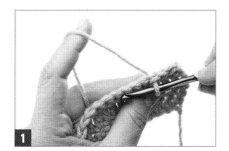

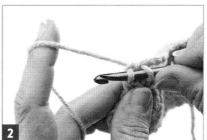

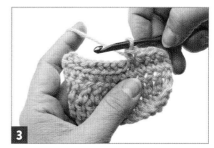

Row 1: Working in front loops only, and with RS facing, sk first st, slip st in each sc across row.

Slip st in the turning ch.

Ch 1, working in the rem loops of the last sc row, sc in each sc across.

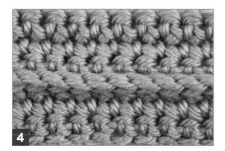

Completed example of Low Front Ridge.

RIBBING USING FRONT POST AND BACK POST

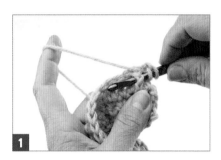

Work a fpdc in the 2nd st of the row.

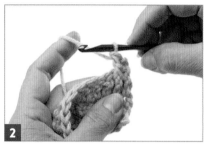

Completed fpdc.

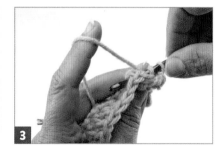

Work a bpdc in the next st.

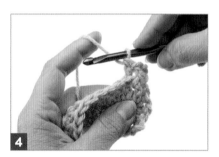

Completed bpdc.

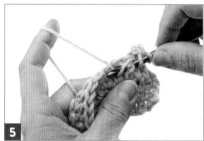

Work a fpdc in the next st.

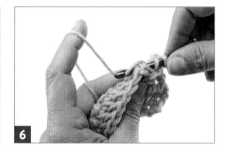

Work a bpdc in the next st. Cont alternating fpdc and bpdc across the row. At the end of the row, turn.

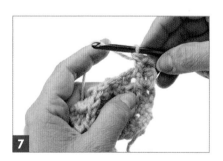

Ch 2 at the beg of the row, *fpdc over the fpdc of the previous row.

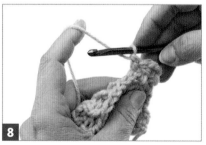

Bpdc over the next bpdc. Repeat from * across.

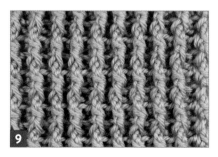

Front view of a ribbing sample.

SINGLE CROCHET RIBBING

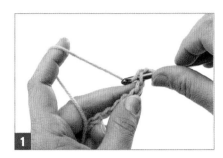

Working along a foundation ch, insert the hook into the 2nd ch from the hook.

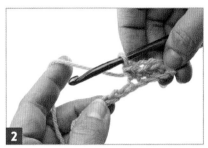

Sc across the row.

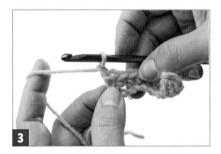

*Ch 1 and turn.

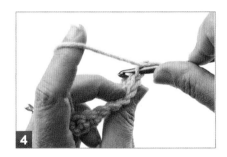

Work in the blps only.

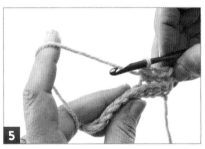

Sc across the row. Repeat from * as needed per pattern.

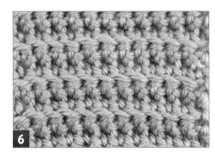

Completed example of sc ribbing.

WATTLE

Row 1: (This example is worked in a chain. Follow pattern instructions when working this stitch, as number of sts skipped may vary.) Starting in third ch from hook, *(sc, ch 1, dc) in next ch. Sk next 2 ch, repeat from * across or as needed per pattern instructions. Turn.

Row 2: Ch 2 (or number pattern requires).

[Sc, ch 1, dc] in each ch-1 space across (or as needed).

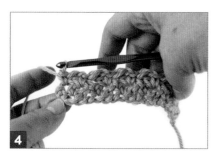

Sc in last sc or ch space, depending on pattern instructions. Repeat Row 2 as needed.

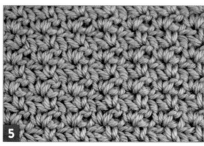

Completed example of Wattle st.

WHEAT CABLE

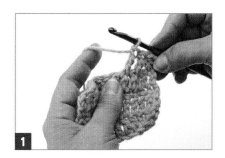

Row 1: *Sk the first 3 sts (when starting from the edge, sk only 2 sts when working across the row). Fptr in each of the next 2 sts.

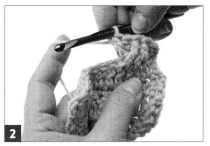

Working behind the last 2 sts, fptr in the last 2 skipped sts.

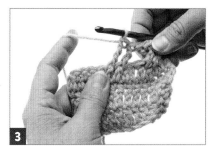

Sk 2 sts, fptr around the next 2 sts.

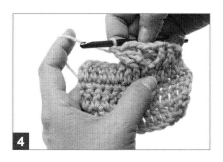

Working in front of the last 2 sts, fptr in the 2 skipped sts. Rep from * to cont Wheat st across the row, ending with a hdc in last st or turning ch. Turn.

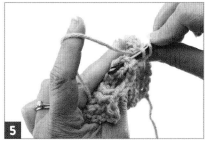

Row 2: Beg next row with the WS facing, ch 2. Work a bpdc in the next st (don't work the end post).

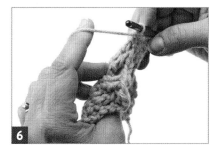

Work bpdc across the row. Dc in the turning ch. Ch 2 at the end of the row. Repeat Rows 1 and 2 for cable pattern.

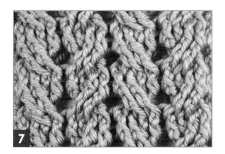

Completed example of Wheat Cable.

WOVEN

Row 1: (Foundation row) Working into a row of sc or dc, ch 2.

Yo the back of the hook.

Insert the hook into the 2nd st of the row.

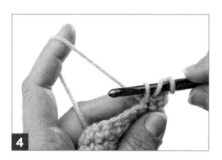

Draw up a lp.

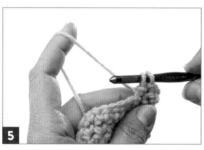

Draw through 1 lp on the hook (2 lps rem on the hook).

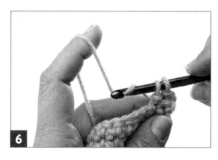

Yo the back of the hook. Draw through 2 lps on the hook.

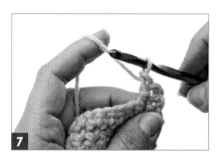

First half of Woven st completed.

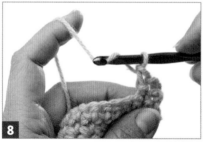

Yo the back of the hook.

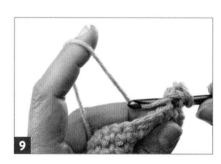

Insert the hook into the same st.

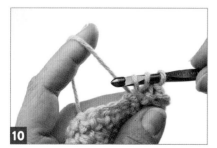

Draw up a lp.

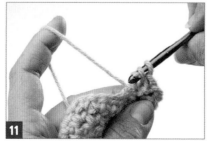

Pull through 2 lps on the hook.

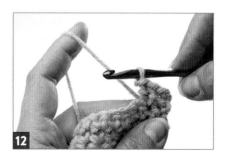

Completed Woven st.

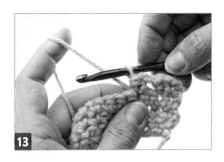

Sk the next sc, work a Woven st in the next sc. Cont to work a Woven st in every other st across the row, turn.

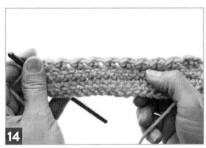

Completed row of Woven sts.

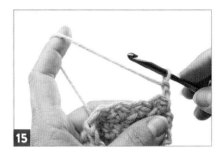

Row 2: Ch 2.

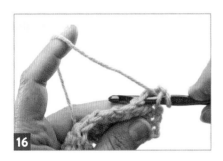

Sts of this row will be worked in between the Woven sts of the prev row rather than in the top lps.

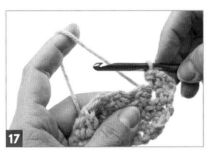

Woven st in between Woven sts across the row.

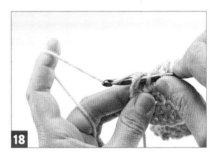

End by working a Woven st in the ch-2 sp. **Row to discontinue Woven st (not shown):** Ch 1, work 2 sc between Woven sts and in the turning ch.

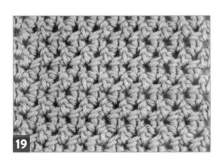

Completed example of Woven st.

Resources

Once again I have the opportunity to thank all those who so generously donated their amazing yarn for the designs in this book. Even though this has become my "work," the joy of receiving your boxes of yarn has not been diminished one bit. In fact, you have taught me to appreciate the beauty of quality fiber even more! I especially want to thank Carly Waterman from Cascade Yarns; Bobbie Matela and Karen Freeman of Red Heart; Jo Ann Walus and Mr. and Mrs. Francis Chester of Cestari Sheep & Wool Company; Luciana López of Malabrigo Yarns; Alison Green of Berroco; Brandyce Pechillo of Lion Brand Yarn Company; Ann of Knitting Fever; and lastly, my sweet friend and fiber genius, Lana Ford, owner of So Original, which remains the *best* local yarn shop in my world!

Berroco, Inc.

1 Tupperware Dr., Suite 4,
N. Smithfield, RI 02896-6815
401-769-1212
www.berroco.com

Blue Sky Alpacas, Inc.

P.O. Box 88
Cedar, MN 55011
763-753-5815
888-460-8862
www.blueskyalpacas.com

Cestari Sheep & Wool Company

3581 Churchville Avenue
Churchville, VA 24421
540-337-7270
www.cestarisheep.com

Juniper Moon Farm

www.fiberfarm.com

Knitting Fever Inc.

P.O. Box 336
315 Bayview Avenue
Amityville, NY 11701
www.knittingfever.com

Lion Brand Yarn

135 Kero Road
Carlstadt, NJ 07072
800-258-YARN (9276)
www.lionbrand.com

Malabrigo Yarn

786-866-6187
www.malabrigoyarn.com

Red Heart

Coats & Clark Consumer Services
P.O. Box 12229
Greenville, SC 29612-0229
800-648-1479
www.redheart.com

Sweet Georgia Yarns

110-408 East Kent Avenue
Vancouver, BC, V5X 2X7 Canada
604-569-6811
sweetgeorgiayarns.com

So Original Yarn Shop

900 Olney Sandy Spring Road
Sandy Spring, MD 20860
301-774-7970
www.sooriginal.com

Acknowledgments

I want to thank the many crocheters who took a chance on me and invested in a copy of my first book, *Contemporary Celtic Crochet.* You truly have made this second publication possible. The encouraging words I have received from many of you have blessed me more than I can express and have lifted me up on those days when I find myself struggling. I so look forward to meeting you someday! It is my hope that this book keeps you, your hooks, and your yarn just as happy as the first.

To Evolve Academy of Germantown, Maryland, for having fantastic wi-fi so that I could work on this book while my son Joseph learns Brazilian Jiu Jitsu. I bet you never thought you'd be mentioned in a crochet book of all things!

Thanks to my special crochet friends: Amy Shelton and Donna Hulka for your continued support and enthusiasm for the art of crochet and crochet designers; MaryJane Hall, my new friend that I feel I've known for years; Nancy Smith, one of the best encouragers I know; Brenda Bourg, for your friendship and sweet support; and Jennifer Ryan, my trusted friend, fellow home-school mom, and sister in the Lord—I'm so very glad we met at that CGOA conference years ago!

To all the kind folks at F+W Media and Interweave Press, thanks for making this book so much better than I imagined. This truly is a team effort! Thank you, Kerry Bogert, for helping to inspire me on the designs and yarn selection for this book. You have expanded my world in both areas, like introducing a child to new candy delights! To Alex Rixey, for responding quickly to all my administrative questions and for helping to protect my published works. To Bethany Carland-Adams,

for all the work you do behind the scenes in order to promote these works. To my editor, Christine Doyle, for taking care of the thousands of details that would drive most people crazy! You are a gift to me. To my tech editor, Charles Voth, thank you for making my patterns so much clearer and accurate, and I truly apologize for all the headaches I must have caused you in the process! And to Chris Dempsey, I am so deeply grateful for your stunning photography.

To my church family at Grace Church of Clarksburg—what can I say? Life in Gaithersburg for my family and me would be so very different without you. I'm so thankful for the privilege to walk out our faith in love and grace with you. Now I know what refined gold looks like in the flesh! A special hug to Vicki Cowan, Stephanie Wethje, and Marilyn Malament for your love, prayers, and care for my soul. I see and feel His light shining through you and count it an honor to be your friend.

To my children, Becky, Caleb, Hannah, Hudson, and Joseph, for putting up with a very distracted mommy who loves you more than she can possibly say. You are my treasure! And to my amazing, brilliant, yet humble husband of twenty-eight years, there is such joy in the journey being by your side. I just can't imagine life without you!

And to THE Master Designer, Jesus Christ, who makes all things possible: "You make known to me the path of life; in your presence there is fullness of joy; at your right hand are pleasures forevermore." (Psalm 16:11)

Metric Conversion Chart

To convert	to	multiply by
Inches	Centimeters	2.54
Centimeters	Inches	0.4
Feet	Centimeters	30.5
Centimeters	Feet	0.03
Yards	Meters	0.9
Meters	Yards	1.1

fw

a content + ecommerce company

www.fwcommunity.com

20 19 18 17 16 5 4 3 2 1

Distributed in Canada by Fraser Direct
100 Armstrong Avenue
Georgetown, ON, Canada L7G 5S4
Tel: (905) 877-4411

Distributed in the U.K. and Europe by F&W MEDIA INTERNATIONAL
Brunel House, Newton Abbot, Devon, TQ12 4PU, England
Tel: (+44) 1626 323200, Fax: (+44) 1626 323319
E-mail: enquiries@fwmedia.com

SRN: 16CR06
ISBN-13: 978-1-63250-353-4

PDF SRN: EP12712
PDF ISBN-13: 978-1-63250-385-5

Edited by Christine Doyle
Designed by Sylvia McArdle
Step-by-step photography by Bonnie Barker
Beauty photography by Chris Demsey
Beauty photography shot at Fat Belly's Irish Pub and Grille
(Providence location) fatbellyspub.com

Dedication

In memory of my husband's grandmother, the late Mrs. Mae Bost. On earth
she was an amazing crocheter who loved her God, family, and even me.
I can't wait to sit down in glory with you, hooks in hand, so you can
teach me some heavenly stitches!

About the Author

BONNIE BARKER is a crochet designer and author who has published more than 100 patterns in books and magazines and for major yarn companies. She is best known for her Aran Isle crochet techniques and is hopelessly in love with crocheted cables and discovering new ways to crochet them! She is a happy wife to her sweet physicist husband, Craig, and is now a thankful, retired homeschool mom of five graduates.

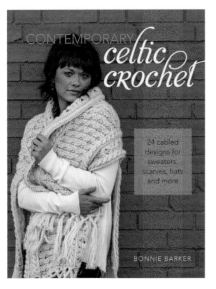